For Mairead

Hard times, hard times
Come again no more.

Table of Contents

The Murals

INTRODUCTION

Murals: a brief history

Loyalists began painting murals early in the twentieth century, even before partition. With partition in 1921, a key task for unionism was to create itself as a 'family', an all-class alliance whose differences were to be subsumed in the interests of the survival of the state against any enemies, internal or external, real or imaginary. This was achieved in part through the reinvigoration of rituals celebrating unionist unity.

Foremost among these rituals was the celebration of the Battle of the Boyne on July 12 ('the Twelfth') 1690, the victory of Prince William of Orange (affectionately known as 'King Billy') over King James for the English throne. Not surprisingly, King Billy figured prominently on the banners carried in parades by the organization formed to honour his victory, the Orange Order. And equally predictably, King Billy constituted by far the main icon in loyalist murals.

The celebration of the Twelfth represented the unionist family at its most emblematic. All differences were either forgotten or air-brushed from the picture.

The myth of unity was remarkably resilient through the decades. But eventually it withered, and quite rapidly, with the social and political changes from the late 1960s on. With the splintering of unionism, the old confidence was gone; the myth of the unionist family was shattered. Not surprisingly, one result was the decline of King Billy murals. In their place, loyalist muralists painted flags, symbols (such as the Red Hand of Ulster), and heraldic designs on the walls. Though seeming to convey an almost timeless sense of grandeur and tradition, they were remarkably soulless. Tellingly, there was no depiction of any living loyalist, nor even of a dead king.

Surprisingly, despite the level of loyalist paramilitary activity throughout the 1970s and early 1980s, there were few representations of armed loyalists in the murals. This changed after the signing of the Anglo-Irish Agreement between London and Dublin in 1985. Unionist opposition was intense, and for a while it almost appeared as if the unionist family had been reconstituted, albeit in opposition rather than state-ruling. As part of that protest, from the summer of 1986 on, military iconography came to predominate in loyalist murals.

Republicans for the most part did not paint murals for the duration of the unionist state. This was due, not least, to the policing, both actual and ideological, of public space by unionism. Nationalists were confined to ghettoes, where they had a vibrant culture, but one which was virtually invisible to the rest of society.

During the hunger strike of 1981, when ten republican prisoners starved to death in pursuit of their demand for prisoner-of-war status, the nationalist community mobilised in support, with protests, pickets and marches. Slogans in support of the hunger strikers' demands were painted on the walls, and eventually they became more ornate; finally murals emerged. Most often these early republican murals depicted specific hunger strikers, in particular Bobby Sands.

With the end of the hunger strike, republican muralists turned their attention to a range of other themes: Sinn Féin's involvement in electoral politics; current political events, in particular issues of police or army repression; Irish history and mythology; and other political struggles internationally, including South Africa, Nicaragua, and Palestine. From the beginning republican muralists represented their

armed struggle in murals. But this theme never predominated in republican murals to the extent it came to do so in loyalist murals.

After the ceasefire: the frustrating politics of transition

For the IRA the danger of declaring a ceasefire in 1994 was that this could be interpreted as a surrender. Certainly loyalists, many unionists, and the British government read the situation as a partial defeat of republicanism. For their part, republicans' involvement in the peace process stemmed from a recognition that neither the British army nor the IRA could win by exclusively military means. Even more fundamentally, republicans astutely concluded that, just as they had been engaged in a 'long war', the time was ripe for a 'long peace' where to call on the state to deliver equality, justice and inclusion was to demand something the state could not deliver without changing radically.

Republicans had been assured that the ceasefire would ensure their inclusion in political talks. But in the immediate aftermath of the IRA ceasefire unionists and the British government began demanding 'actual decommissioning' of weapons as a prerequisite to such talks. US Senator George Mitchell was asked to mediate in January 1996 and proposed that decommissioning and negotiations proceed in parallel. The British government rejected this, and called elections for a new Assembly to meet at Stormont, the former seat of unionist rule. Supporting a devolutionist assembly was thought to be a step too far for republicans, but they participated in the elections, with impressive results. Despite this, seventeen months after the IRA ceasefire there was little to show in terms of political progress. The IRA ended its ceasefire by bombing the Docklands area of London. 'All-party talks' (sic) began in June 1996, with Sinn Féin excluded.

Shortly after the election of a New Labour government under Tony Blair, the IRA ceasefire was reinstated in July 1997. An attempt was then made to separate the issues of decommissioning and negotiations with the establishment of an Independent Commission on Decommissioning (ICD) to meet republican and loyalist representatives in an attempt to find a solution to the arms issue. Although the IRA stated it had no intention of disarming, in September 1997, Sinn Féin attended all-party talks for the first time. Seven months later, on 10 April 1998, the Belfast – or Good Friday – Agreement was signed by all the negotiating parties. The way now seemed open for the formation of a power-sharing executive, with ministerial posts allocated in proportion to each party's success in Assembly elections.

Under pressure from anti-Agreement unionists in his own party, Ulster Unionist Party (UUP) leader David Trimble insisted on 'no guns, no government' and refused to expedite the formation of the executive. Eventually, in November 1999, the IRA appointed representatives to the ICD and the executive was formed with Trimble as first minister.

But Trimble, struggling to maintain a pro-Agreement majority in his party's governing body, continued to demand decommissioning. At the beginning of 2000, he threatened to resign due to lack of progress on the issue. The ICD reported on 11 February 2000 that no progress had taken place, and although a further report later that same day did appear more positive, Secretary of State Peter Mandelson claimed not to have received the second report in time and suspended the executive. The IRA withdrew its representatives from the ICD. It was May 2000 before arrangements were made to allow the executive to be restored and Trimble to have a majority (only just) of his party backing his return. These arrangements included the IRA's determination to put some arms 'completely and verifiably beyond use' and its agreement that two international observers could examine their sealed arms dumps. Finally in October 2001 the ICD announced the disposal of a significant number of weapons. A second such announcement followed in April 2002.

The executive was suspended on four occasions over various political crises. The fourth suspension, on October 14, 2002, seemed the most serious. While Trimble had threatened once again to resign by January 2003 unless there was substantial progress on a number of issues, including republican decommissioning, the timely emergence of allegations of an IRA intelligence-gathering operation at Stormont provided the perfect opportunity to pass the responsibility to the British Secretary of State, who suspended the executive indefinitely.

Remarkably little was said during this undulating debate about loyalist arms. The main loyalist paramilitary groups, the UDA and the UVF, had declared a joint ceasefire six weeks after that of the IRA, in October 1994. But the loyalist parties with links to these groups – the Ulster Democratic Party and the Progressive Unionist Party respectively – had relatively little success in garnering working class support. Although the UDP managed to gain a small number of council seats, they had no representatives elected to the Assembly. It became clear that the UDP was out on a limb, with many in the UDA increasingly opposed to the peace process. The party was eventually disbanded in 2001.

The PUP was on stronger ground with its paramilitary grass roots. It had two representatives elected to the Assembly, but this was not enough to allow them to appoint any ministers to the executive. Thus even PUP supporters came to feel somewhat marginal to the political process. Moreover many loyalists, of whatever hue, were convinced that the peace process was inevitably a zero-sum game, where advances for nationalists and republicans necessarily meant losses for unionists and loyalists. Increasingly the UDA in particular escalated its attacks against nationalists through blockades of nationalist areas, harassment of school children, the pipe-bombing of homes and the murder of young nationalist men. At the core of their strategy was the unsuccessful attempt to draw the IRA's fire, allowing the UDA to cast itself in its traditional role of defender of loyalist areas and to expose the IRA ceasefire as a sham. Eventually, in October 2001 Secretary of State John Reid declared the obvious, that the UDA ceasefire was no longer in existence.

Periodically loyalist weapons were turned on fellow loyalists. To take one instance: a feud in Belfast's lower Shankill Road area in the summer of 2000 led to 13 deaths and the forced removal of perhaps 1,000 residents as the area sorted itself into exclusive UDA and UVF territories. By the end of the period loyalist politics appeared to be dominated by the desire to acquire and maintain control of territory rather than to advance the peace process.

The changing face of Republican murals

From 1996 on, republican murals frequently commented on political developments and issues such as the Westminster election in 1997, when Gerry Adams took back the West Belfast seat he had held up to five years previously (**plate 1**). Much more problematic was the need to explain republican involvement in a devolved assembly at Stormont to the grassroots. Republican muralists rose imaginatively to the task. The first prime minister of Northern Ireland, James Craig had once boasted of 'a Protestant parliament for a Protestant people'. Amending an image from events in Eastern Europe a decade previously, republican muralists depicted a crowd pulling down the statue of Lord Carson, the architect of the Northern Ireland state, which dominates the avenue approaching Stormont (**plate 2**). Republicans were thus depicted as entering the Stormont building without supporting the old order of unionist domination. Another mural (**plate 3**) reiterated the point that this was not an 'internal settlement'. The failure of Trimble and Blair to expedite the formation of the executive was treated in a number of murals (**plates 4 and 5**). And decommissioning was specifically referred to in a mural which recalled the attack of loyalists on nationalist Bombay Street in 1969 and the continuing need for defence: 'decommission, no mission' (**plate 6**).

When Secretary of State Peter Mandelson disbanded the Assembly in February 2000 despite a last-minute communiqué from the ICD, he was portrayed as Pinocchio, dancing to unionism's tune (**plate 7**). When he resigned the following year amid claims of involvement in the attempt of two Indian businessmen to acquire British passports, the mural was reprised, with the addition of an amended version of Barry Manilow's song, 'Mandy' (**plate 8**). The Pinocchio reference relates to Mandelson's apparent tendency to be economical with the truth on both occasions.

A central aspiration of the Good Friday Agreement was that everyone should be able to live free from sectarian harassment. There were many opportunities to point out that reality fell far short of that aspiration. One mural (**plate 9**) amended the cover of the Agreement booklet which had been sent to every home, while in another the film poster of Stanley Kubrick's 'A Clockwork Orange' was the inspiration for an ingenious mural (**plate 10**). A recurrent problem was the demand of Orange marchers to pass through nationalist areas such as Garvaghy Road, Portadown. One Portadown mural celebrated nationalist culture by portraying three Irish dancers (**plate 11**). The image was repeated on the same wall the following year; referring to the annual siege of the area by Orange marchers from nearby Drumcree church, an Orangeman with a petrol bomb towers over the three dancers (**plate 12**). A few days later, three young nationalist boys were burnt to death in a petrol bomb attack on their home in Ballymoney, the attack linked to the ongoing Drumcree march. 'Not all traditions deserve respect' noted another mural, referring to the plight of the residents of Garvaghy Road (**plate 13**). As for the residents of the Lower Ormeau Road, Belfast, one mural depicted Secretary of State Mo Mowlam, like Pilate, washing her hands, while a police chief indicates that the approved route for Orange marchers was over any nationalist in the way (**plate 14**). A nearby mural the following year showed the community imprisoned to allow the marchers to exercise their 'right to march' (**plate 15**). It was not only in relation to marches that there was a claim that the peace process had not delivered. The tiny nationalist area of Short Strand in East Belfast was in effect besieged by anti-Agreement loyalists in the spring and summer of 2002. One mural, copied from a cartoon in the daily *Irish News*, depicted their plight (**plate 16**). Earlier, school girls from nationalist Ardoyne had to run a gauntlet of missiles and verbal abuse to get to their school, Holy Cross, situated in the adjoining loyalist area. The situation was compared to that of African-American high school pupils in Arkansas in 1957 (**plate 17**).

A number of murals referred to republican prisoners. Roisin McAliskey was arrested and imprisoned in England pending an extradition order from Germany in relation to an IRA bomb in Osnabrück (**plate 18**). She was eventually released in April 1998 on health grounds. And in 2001, three Irish men were arrested in Colombia on charges of training FARC insurgents. The campaign to 'bring them home' featured in a number of murals (**plate 19**). More generally, a mural in Belfast depicted the history of republican prison protest, including internment and the hunger strike (**plate 20**). The mural was part of the campaign, called Saoirse (Freedom), to have all the political prisoners released, as promised by the Good Friday Agreement. The final releases came in summer 2000.

After the ceasefire a number of republican murals called for the departure of British troops and the disbanding of the police force, the RUC. The most famous 'troops out' mural, painted originally in Ardoyne in 1994, was reproduced in Short Strand in 1997 (**plate 21**). As regards policing, a government committee headed by Chris Patten had suggested a number of reforms; although these fell short of the maximum demands of republicans, the British government further watered down the package. Consequently, Sinn Féin was not persuaded to support the new Police Service of Northern Ireland. A number of murals related to this heated debate. They called for the disbandment of the

RUC (**plate 22**), referring to the force's involvement in collusion in many loyalist murders, including those of solicitors Pat Finucane in 1989 and Rosemary Nelson in 1999 (**plate 23**), and to the fact that there was no discernible difference between the unionist RUC and the Orange Order (**plate 24**). While some murals reminded viewers of past oppression and resistance (**plate 25**), others stated that nothing had changed (**plate 26**).

Such repression was often carried out with virtual impunity. Thus, two British soldiers who had shot dead an unarmed Belfast teenager, Peter McBride, in 1992 had been found guilty of murder, but served only two years in prison and on their release were reinstated in their regiment, the Scots Guards (**plate 27**). This was compared to the situation for released political prisoners who continued to face discrimination in relation to a number of occupations and social benefits. Nor was any RUC man or British soldier found guilty for the deaths of seventeen people, many of them children, by rubber and plastic bullets (**plates 28-30**).

In the immediate aftermath of the IRA ceasefire, images of the armed struggle quickly disappeared. Although occasionally some new militaristic murals appeared – for example, the acknowledgement of the end of the ceasefire with the London Docklands bombing (**plate 31**) – these were exceptions which proved the rule. The only guns or references to armed struggle were now mainly confined to memorial murals commemorating dead comrades: such as that the three IRA volunteers – Mairead Farrell, Sean Savage and Dan McCann – killed by British undercover operatives in Gibraltar in 1988 (**Plate 32**), and celebrations of the role played by women in the struggle of the previous three decades (**plates 33 and 34**). In the Ballymurphy area of west Belfast in 2001 and 2002 nine murals were painted which superficially seemed to proclaim the end of the moratorium on militaristic murals. However, closer examination reveals that, despite the prevalence of guns, these murals were about the past, not the present. The IRA members depicted were real people, not masked ciphers. These were monuments to members of the local community who had died during the war: Jim Bryson and Paddy Mulvenna, shot by British soldiers in August 1973 (**plate 35**); Pearse Jordan (shot by the RUC, November 1992), Bobby McCrudden (shot by British soldiers, August 1972) and Mondo O'Rawe (shot by British soldiers, April 1973) (**plate 36**); Tommy Tolan (killed in a feud with the Official IRA, July 1977), James McGrillen (shot by British soldiers in February 1976), and Michael Kane and John Stone (killed in premature bomb explosions in September 1970 and January 1975 respectively) (**plate 37**); and local IRA members on patrol (**plate 38**). Also significant was the way community support for the IRA was represented; Tommy Tolan and his active service unit, for example, are depicted, heavily armed, having a meal in a local safe house.

In the same spirit of commemoration, murals appeared periodically referring to the 1981 hunger strike. This reached a climax in 2001, when for the twentieth anniversary a large number of murals appeared reprising the themes and images of two decades earlier: popular support for the hunger strike (**plate 39**), or 'comms', letters smuggled out of prison (**plate 40**). Various hunger strikers were depicted: Mickey Devine (**plate 41**), Kieran Doherty (**plate 42**), Joe McDonnell (**plate 43**), all ten hunger strikers (**plate 44**), and Bobby Sands (**plate 45, and book cover**).

As before the ceasefire, mythology and history proved rich seams for republican muralists to mine. Cuchulainn (**plate 46**) and Celtic warriors (**plate 47**) were occasionally depicted. The murals on historical themes covered a wide gamut of Irish history: the mass rock (**plate 48**) and the hedge row schools (**plate 49**) of penal law days; the 1798 United Irishmen rebellion and some of its heroes, Henry Joy McCracken and his sister Mary Ann (**plate 50**); the gun-running from Germany aboard the Asgard in July 1914 (**plate 51**), and events surrounding the 1916 Easter Rising and the War of Independence:

James Connolly and Patrick Pearse in the General Post Office in Dublin (**plate 52**), and all the signatories of the Proclamation of the Republic (**plate 53**); and the activities of Cumann na mBan (**plate 54**). The last mentioned also featured portraits of Winnie Carney, James Connolly's secretary and a life-long socialist, and Nora Connolly, daughter of James. Closer to the present day, the murder of 14 civil rights protesters on Bloody Sunday, January 1972 is recalled in a mural painted by the Bogside Artists near Free Derry Corner (**plate 55**).

As anti-imperialists, republican muralists could identify with similar struggles elsewhere. Murals appeared on topics as diverse as the death on hunger strike of Sevgi Erdogan, a member of the Turkish Revolutionary People's Liberation Party-Front, in July 2001 (**plate 56**) and protests by Australian aboriginals over the theft of their ancestral land (**plate 57**). Two of the most important political icons of the twentieth century were also depicted: Malcolm X, painted by North American muralist Mike Alewitz (**plate 58**), and Che Guevara, the latter shown beside a group of Irish republican prisoners, including Bobby Sands, reading one of his books (**plate 59**). ETA's campaign for Basque independence was painted by three young Basques living in Belfast (**plate 60**), while the plight of Palestinians under Israeli occupation inspired another mural (**plate 61**).

When a US firm, Raytheon, opened in Derry, many saw this as a sign of the economic revival of the area. But others, aware of Raytheon's role in the manufacture of software used in computers targeting missiles on such places as East Timor, were much more critical (**plate 62**). Two political prisoners in the US, both of them highly articulate and both claiming their innocence – Leonard Peltier, who is serving two life sentences for the 1975 murders of two FBI agents during a siege at the Pine Ridge Reservation in South Dakota (**plate 63**), and Mumia Abu-Jamal, on death row following the death of a policeman in Philadelphia in 1982 (**plate 64**) – figured in separate murals. Martin Luther King looked down from boards in North Belfast (**plate 65**), while in South Belfast it was the face of another black man (**plate 66**). Stephen Lawrence was stabbed to death by racists in South London in April 1993. The Metropolitan police were quick to see this as the result of a racial squabble rather than a racist attack, and slow to look for the offenders. An official inquiry found the force guilty of 'institutionalised racism'. In Portadown, a nationalist man, Robert Hamill, returning from a bar in May 1997 was kicked unconscious by a crowd of loyalists while four armed police sat nearby in an armoured vehicle without intervening. He died later in hospital. The mural's message is that this is proof of 'institutionalised sectarianism'.

Finally, there were murals painted on various other themes: violence against women (**plate 67**), the murder of nationalist black taxi drivers by loyalists (**plate 68**), and the Travelling community (**plate 69**). Painted in conjunction with a group of young Traveller women, the message of this last mural was that Ireland's very own racialised minority has a strong and proud history and culture.

What we have we hold: Loyalist murals

Unlike republican murals, loyalist murals after their ceasefire of October 1994 made few references to topical political events and developments. One exception was the demand for the release of political prisoners (**plate 70**). Another was a rejection of Sinn Féin's claim of commitment to the peace process, depicting their alleged involvement in gun-running from Florida, stealing intelligence files from police headquarters in Castlereagh, training guerrillas in Colombia, and running a spy ring at Stormont (**plate 71**). Surprisingly, given the conflict over Orange marches, few murals referred to the subject, and none sought to explain why people would want to march in the face of local community opposition. One referred to the annual parade from Drumcree church, but did not portray the confrontation which regularly occurred (**plate

72), while another at least revealed the motivation of some marchers: playing loyalist music in an area where the band was not wanted was more exciting than in an area where it was accepted (**plate 73**).

There were no murals demanding decommissioning by the IRA, urging people to vote for loyalist candidates for the new Assembly or criticising David Trimble for doing too much or too little. Instead, as before the ceasefire, the bulk of loyalist murals were militaristic. Some showed live loyalist heroes such as UDA man Michael Stone, who had killed three mourners at the funeral of the three IRA volunteers shot dead in Gibraltar in 1988 (**plate 74**), or Johnny Adair, imprisoned after a feud on the Shankill in 2000 (**plate 75**).

But the more common depiction was of masked and armed men in action (**plates 76 to 82**). One UVF mural reprised another painted immediately after the ceasefire (**plate 77**); when the building on which the original mural was painted was demolished, a new wall was built nearby and the image recreated. The Red Hand Commando confused some by using Gaelic (**plate 81**), a reference to the symbol, the red hand of Ulster, and slogan – 'Lamh dearg abu' – of the main northern clan in Elizabethan times, the O'Neills. The loyalist groups more normally tended to raid standard British army symbolism; the UVF, for example, likened themselves to the prestigious SAS by quoting the words of the regimental memorial at the SAS headquarters in Credenhill (**plate 82**).

A number of fictional characters were dragooned for the loyalist cause, among them Eddie, who features on album covers of the heavy metal group Iron Maiden (**plates 83 and 84**), Cuchulainn (**plate 85**), and even Finn McCool, the mythological giant who created the Giant's Causeway on the north Antrim coast (**plate 86**). The Eddie murals proliferated, with at least six in Belfast by 2002 as well as one in Long Kesh prison, and were among the most chilling of all loyalist murals. The accompanying slogans to the two examples shown here show little sign of a commitment to exclusively democratic or peaceful politics; the Tavanagh Street mural warns: '… So when you're in your bed at night and hear soft footsteps fall, Be careful it's not the UFF and reaper come to call.' The Carrickfergus mural depicts three crosses, each with the name of a living prominent member of Sinn Féin. Cuchulainn is a mythological character normally associated with the 1916 Rising, but attempts were made to transform him into a loyalist hero, defender of Ulster from attacks by the army of Connacht.

The loyalist over-reliance on militaristic imagery had a number of reasons. One was to reassure their communities that loyalists continued to carry out the role which was their raison d'être, defence. Another was to warn nationalists to beware. Increasingly, however, the warning was to fellow loyalists, as feuds and ongoing disputes led to attempts to create single-party areas. In short, loyalist murals were overwhelmingly about territory, and frequently informed 'outsiders', loyalist as well as nationalist, who was top dog in the area (**plate 87**).

Beyond the explicit and often threatening representations of armed men and mythological warriors recruited to the loyalist cause, there were memorials to dead colleagues, including: Joe Bratty, UDA leader in South Belfast, killed by the IRA one month before their ceasefire in 1994 (**plate 88**); Ernie 'Duke' Elliot of the Woodvale Defence Association, precursor of the UDA, killed by fellow loyalists in 1972 in an internal dispute over weapons (**plate 89**); William 'Bucky' McCullough, a UDA leader in the Shankill area, killed by the INLA in 1981 after having been set up by UDA informer Jim Craig (**plate 90**); Billy Wright, founder of the LVF, shot dead by the INLA in Long Kesh in 1997 (**plate 91**); Cecil McKnight, a member of the UDP, killed by the IRA in June 1991 (**plate 92**); Stevie McCrea, a member of the Red Hand Commando killed by the Irish People's Liberation Organisation in 1989 (**plate 93**); and Sam Rockett of

the Young Citizen Volunteers, youth wing of the UVF, killed during the loyalist feud on the Shankill in 2000 (**plate 94**).

It was often difficult to find murals on anything other than military themes. However, the UVF had one advantage over the UDA in being able to refer to its history, specifically its roots in the original UVF. Formed to oppose Home Rule, the UVF entered the British army as the 36th Ulster Division and was decimated at the Battle of the Somme in July 1916. Numerous depictions of the war and occasionally of those who gained Victoria Crosses for bravery are to be found in areas where the UVF is dominant (**plates 95 to 97**).

More recently even the UDA has begun to explore historical themes in its murals. The 1641 rising, which almost wiped out the plantation of Ulster in its early years, has been treated in one mural, albeit with the date wrongly identified as 1600 (**plate 98**). The same mural uses the more modern phrase 'ethnic cleansing', a phrase also used in another mural which refers to both opposition to Home Rule and defence against IRA activities in the border region in the 1970s (**plate 99**). Oliver Cromwell's bloody campaign in Ireland is treated sympathetically as an early attempt to obliterate Catholic rebellion (**plate 100**). The events surrounding the Williamite wars in Ireland figure also, including the apprentices closing the gates of Derry against the Jacobite army in 1689 (**plate 101**). Also, despite the overall decline, King Billy murals appeared occasionally (**plate 102**). Finally, a more recent historical event, the Ulster Workers' Council strike, when loyalists brought down the power-sharing executive in 1974, is treated in two murals (**plates 103 and 104**).

Most loyalist murals are directly commissioned by paramilitary groups. However, the official recognition – and funding – of the Ulster-Scots movement in the aftermath of the Good Friday Agreement has providing a new source of commissioning, and hence a boost to the emergence of murals on historical themes – in particular US presidents of Ulster-Scots ancestry or with some connection to that emigrant group in the US – James Buchanan (whose ancestors came from County Donegal) (**plate 105**), George Washington (**plate 106**) – and other Ulster-Scots heroes in America – such as frontiersman Davy Crockett (whose ancestors came from County Derry) (**plate 107**). Other such murals have celebrated St Patrick as a 'British saint' rather than Irish (**plate 108**), and the Ulster-Scots language (**plate 109**) and history (**plate 110**). As an attempt to create or recreate a different identity for northern unionists than either of the traditional ones on offer – as Irish or British – the Ulster-Scots movement is in its infancy; the odds on its ultimate success are unpredictable. Given that, some murals head for the surer ground of the tried and tested identity of being British. Thus the 50th anniversary of Queen Elizabeth II's accession to the throne (**plates 111 and 112**), the death of the Queen Mother in the same year (**plate 113**) and the lingering memory of the popularity of Lady Diana (**plate 114**) have all been acknowledged on the walls.

Finally, after a period of prolonged tension and internecine killing, the UDA ousted Johnny Adair's supporters from the lower Shankill in January 2003. In taking more control of the organisation, the leaders shortly afterwards removed paramilitary flags from their areas and ordered the painting out of a number of murals, including some of the more heavily paramilitary ones pictured here. How widespread the move away from paramilitary themes will be and what, if any, images will be found to replace them remains to be seen.

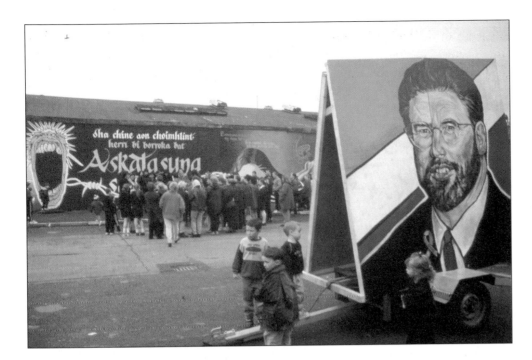

Plate 1
Beechmount Grove, Belfast 1997
Mobile Westminster general election
mural for Gerry Adams; in
background, dedication of Basque
mural (see plate 60)

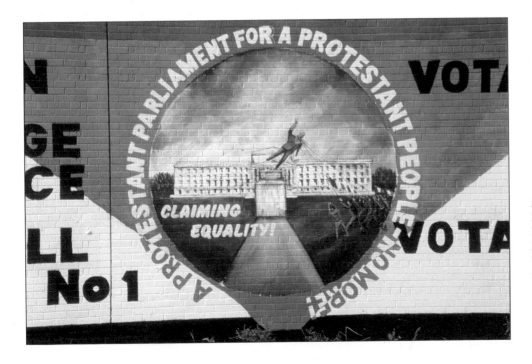

Plate 2
Mountpottinger Road, Belfast 1998
Republicans pull down statue of Sir
Edward Carson outside Stormont
building. 'A Protestant parliament
for a Protestant people – no more!'

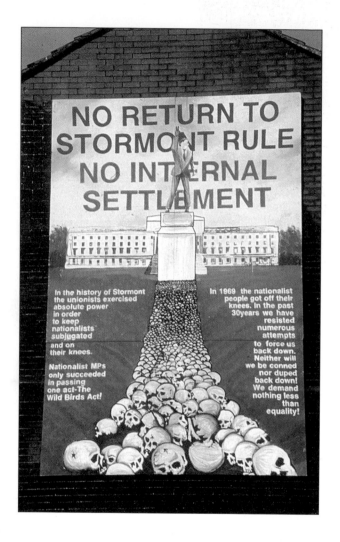

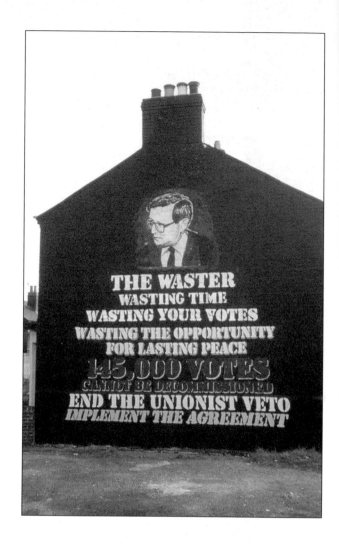

Plate 3
Ardoyne Avenue, Belfast 1998
Road to Stormont paved with the skulls of nationalist victims
of unionist one-party rule. 'No return to Stormont rule; no
internal settlement… We demand nothing less than equality

Plate 4
Falls Road, Belfast 1999
Portrait of David Trimble, characterised as 'The Waster'
for 'wasting the opportunity for lasting peace'. 'End the
unionist veto; implement the Agreeement.'

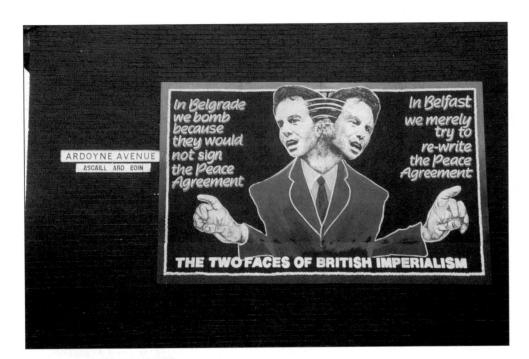

Plate 5
Ardoyne Avenue, Belfast 1999
Portrait of 'two-faced' Tony Blair.
'The two faces of British
imperialism.'

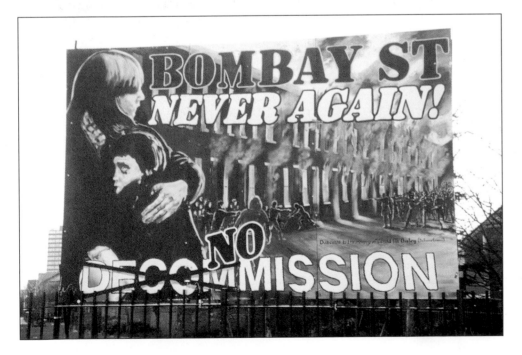

Plate 6
Falls Road, Belfast 1999
Loyalists burn Bombay Street,
Belfast in August 1969.
'Bombay St, never again!
Decommission – no mission.'

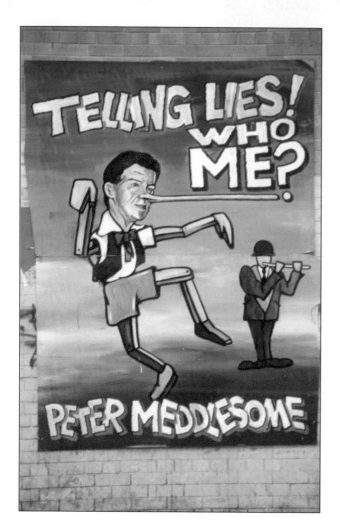

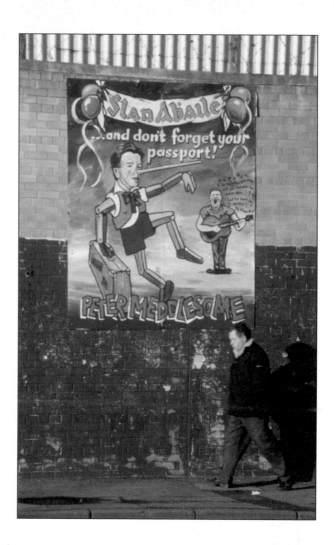

Plate 7
Falls Road, Belfast 2000
Secretary of State Peter Mandelson ('Peter Meddlesome')
caricatured as Pinocchio, a puppet dancing to the tune of a
loyalist flute player. 'Telling Lies! Who me?'

Plate 8
Falls Road, Belfast 2001
Peter Mandelson ('Peter Meddlesome') as Pinocchio, with
packed suitcase as he resigns from office over Hinduja
brothers' passport affair. 'Slán Abhaile (safe home)… and
don't forget your passport!'

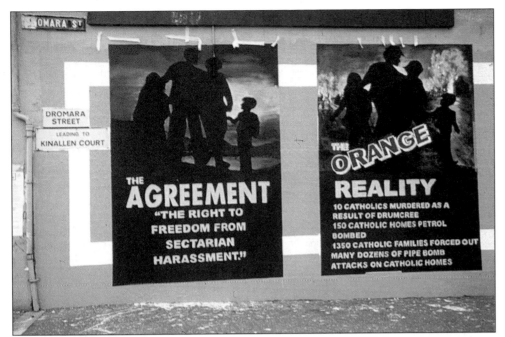

Plate 9
Dromara Street, Belfast 1999
The promises of the Good Friday
Agreement contrasted with the
reality of continuing loyalist
sectarian harassment and violence.

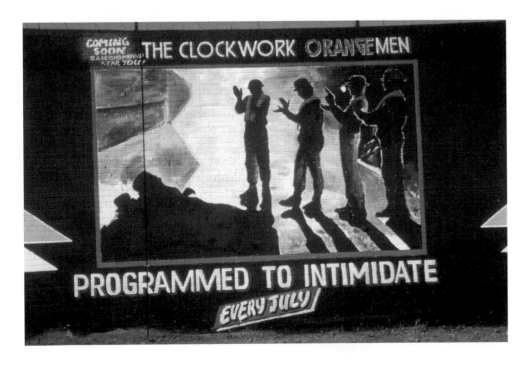

Plate 10
Mountpottinger Road, Belfast 2000
Bowler-hatted thugs wearing Orange
Order sashes. 'Coming soon to a
neighbourhood near you, the
Clockwork Orangemen. Programmed
to intimidate every July.'

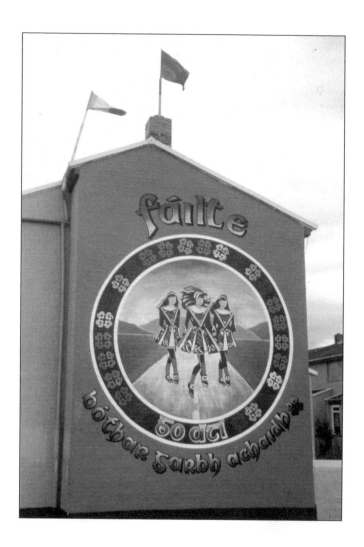

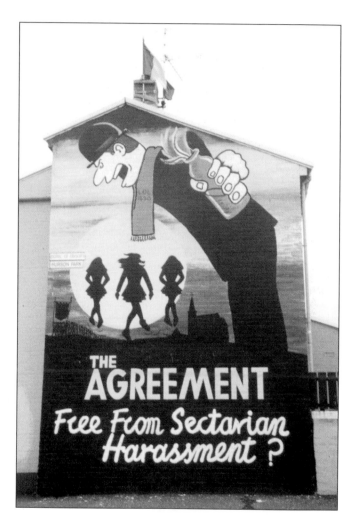

Plate 11
Hurson Park, Portadown, County Armagh 1997
Three girls performing Irish dances on a road.
'Fáilte go dti Bothar Garbh Achaidh – Welcome to
Garvaghy Road.'

Plate 12
Hurson Park, Portadown, County Armagh 1998
Irish dancers with looming Orangeman brandishing
petrol bomb, silhouettes of Orange marchers and
Drumcree church. 'The Agreement: free from
sectarian harassment?'

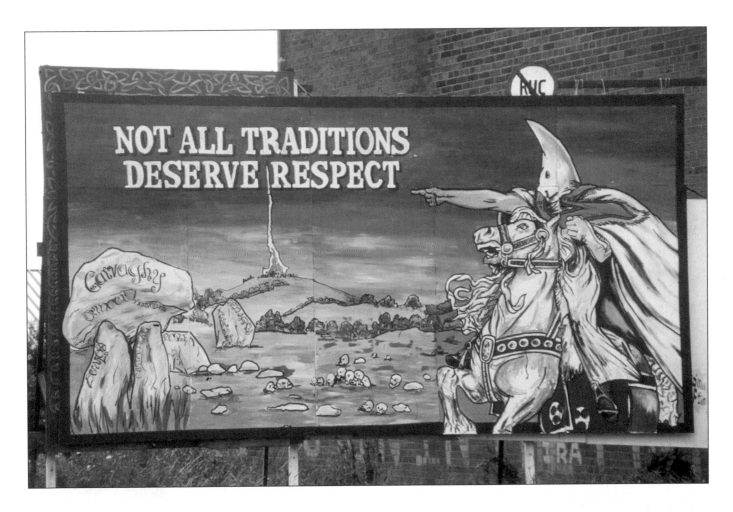

Plate 13
Falls Road, Belfast 1996
Hooded figure wearing Orange Order sash, on horseback, pointing to dolmen inscribed with words 'Garvaghy Road', skulls and fire. 'Not all traditions deserve respect.'

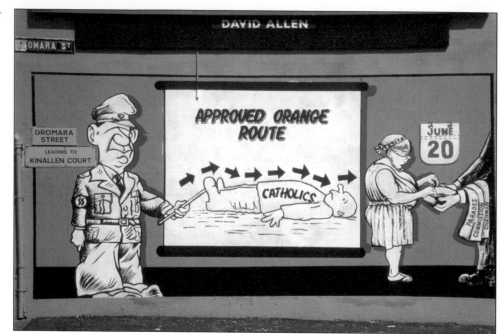

Plate 14
Dromara Street, Belfast 1997
Secretary of State Mo Mowlam,
blindfolded, washes hands while
RUC officer, sporting 'SS' armband,
indicates approved route for Orange
march through nationalist Lower
Ormeau Road.

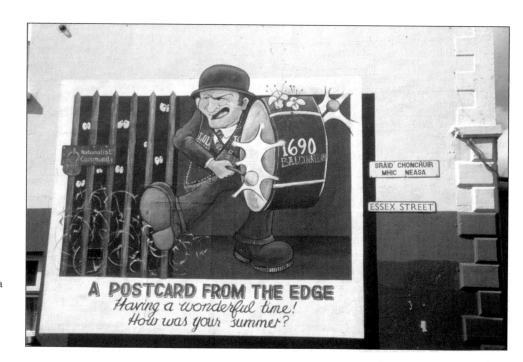

Plate 15
Essex Street, Belfast 1998
Drum-playing Orange marcher
passes while nationalist community
watches from behind locked gates.
'A postcard from the edge. Having a
wonderful time! How was your
summer?'

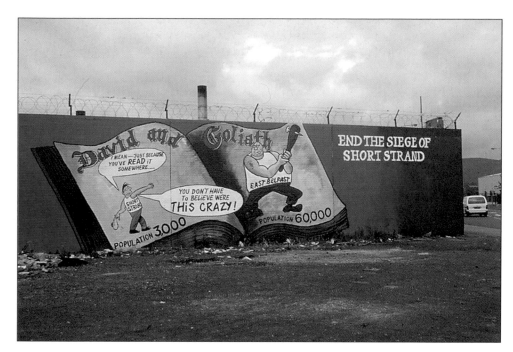

Plate 16
Mountpottinger Road, Belfast 2002
Cartoon representing nationalist
Short Strand area as David and
unionist East Belfast as Goliath.
'End the siege of Short Strand.'

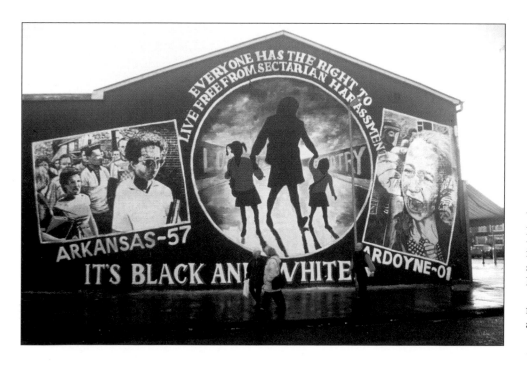

Plate 17
Ardoyne Road, Belfast 2001
Harassment of black school children
in Arkansas 1957 and nationalist
school children on their way to
Holy Cross School, Ardoyne, 2001.
'Everyone has the right to live free
from sectarian harassment. It's black
and white.'

9

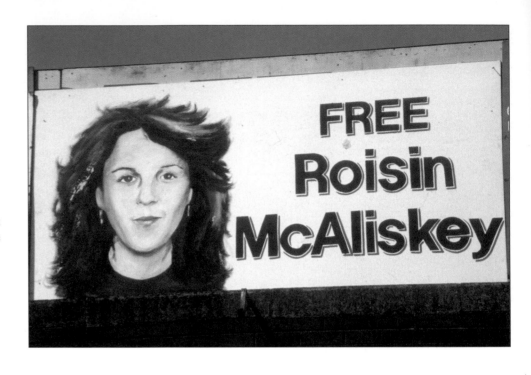

Plate 18
Andersonstown Road, Belfast 1998
Portrait of Roisin McAliskey. 'Free
Roisin McAliskey.'

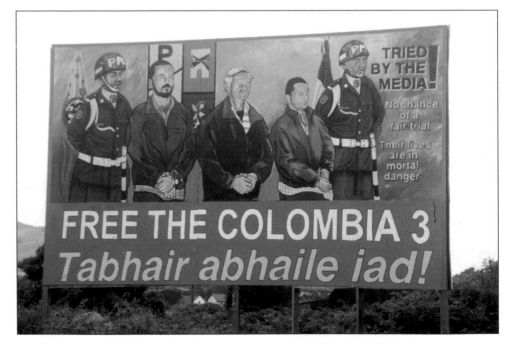

Plate 19
Killeen, near border between
Northern Ireland and Republic, 2002
Portraits of Niall Connolly, Jim
Monaghan and Martin McCauley,
with Colombian military. 'Free the
Colombia 3. Tabhair abhaile iad
(bring them home).'

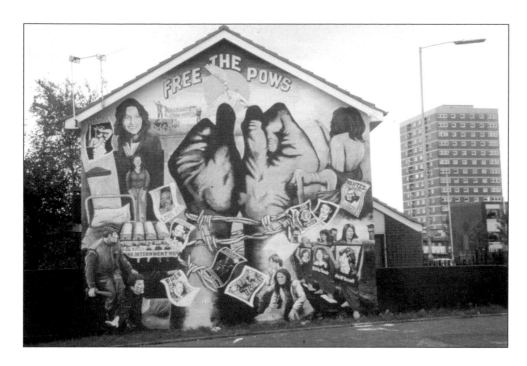

Plate 20
New Lodge Road, Belfast 1997
Portraits of Mairead Farrell and
1981 hunger strikers, references to
internment and prison protest. 'Free
the POWs (prisoners of war).'

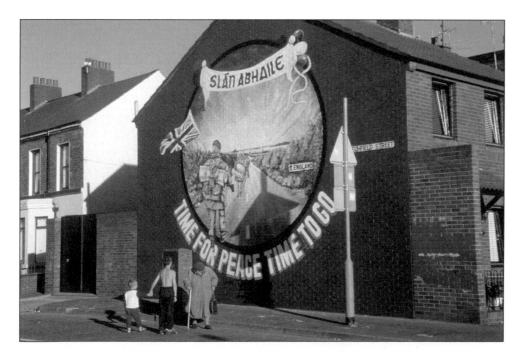

Plate 21
Beechfield Street, Belfast 1997
British soldiers returning to
England. 'Slán Abhaile (safe home).
Time for peace. Time to go.'

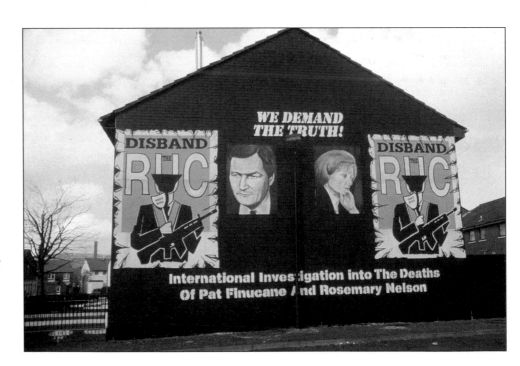

Plate 22
Cromac Street, Belfast 1999
Crystal ball reveals future edition of
Irish News announcing disbandment
of RUC. 'Looking for lasting peace.
Disband the RUC.'

Plate 23
Ardoyne Avenue, Belfast 1999
Portraits of murdered lawyers Pat
Finucane and Rosemary Nelson,
armed RUC men with Orange Order
sashes and 'murder gang' masks.
'We demand the truth. International
investigation into the deaths of Pat
Finucane and Rosemary Nelson.'

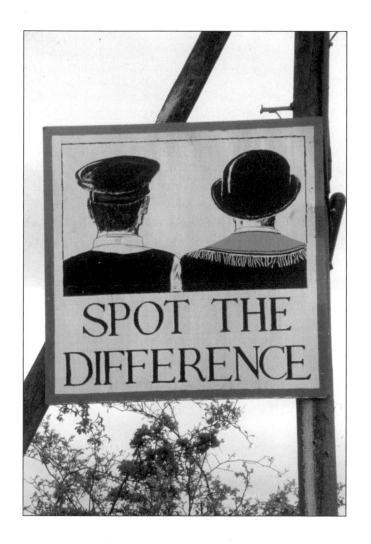

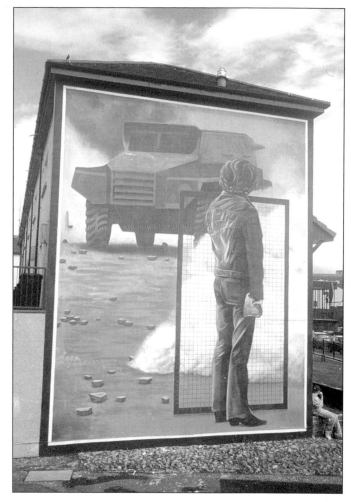

Plate 24
Camlough, County Armagh 1997
RUC man and Orange Order member. 'Spot
the difference.'

Plate 25
Rossville Street, Derry 2001
Lone nationalist protester faces oncoming British
army Saracen.

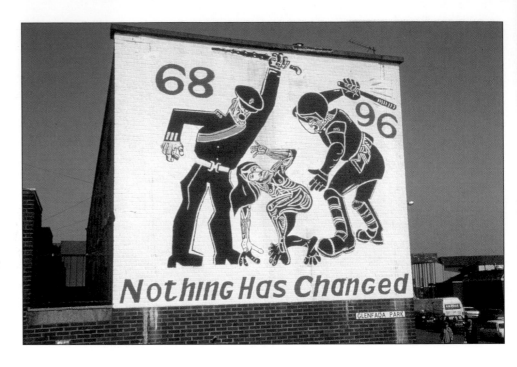

Plate 26
Rossville Street, Derry 1996
RUC man, wearing Orange sash, beats victim with blackthorn stick, 1968, and RUC man in full riot gear beats victim with baton, 1996.
'Nothing has changed.'

Plate 27
Rockdale Street, Belfast 2001
Portraits of Scots Guardsmen Mark Wright and Jim Fisher, jailed for murder of Peter McBride; continuing discrimination against republican ex-prisoners.
'Cohionannas do gach duine (Equality for all).'

14

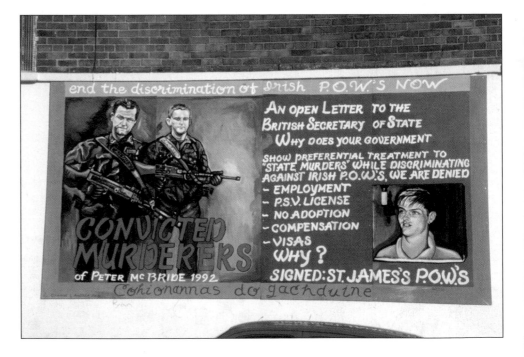

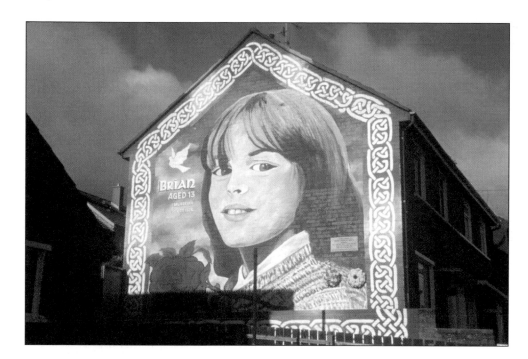

Plate 28
Norglen Road, Belfast 2001
Portrait of Brian Stewart, plastic
bullet victim.

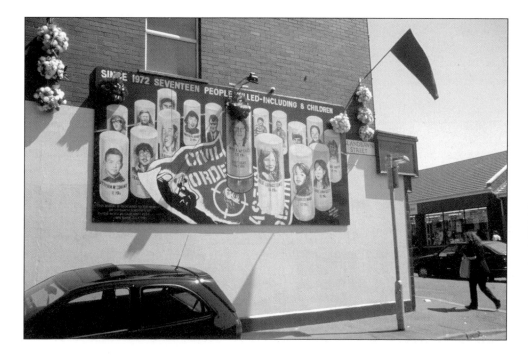

Plate 29
Islandbawn Street, Belfast 2000
Portraits of plastic bullet victims.
'Since 1972 seventeen people killed
– including 8 children.'

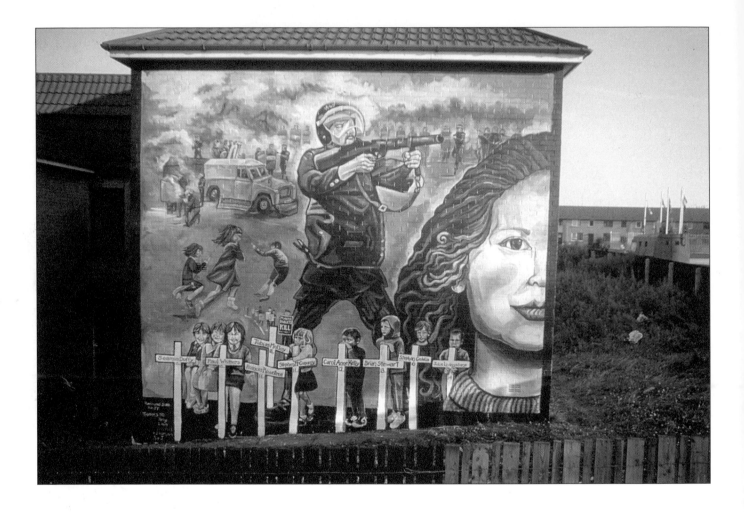

Plate 30
Twinbrook Road, Belfast July 2000
RUC man firing plastic bullet gun, children
with crosses bearing names of nine young
people killed by plastic bullets.

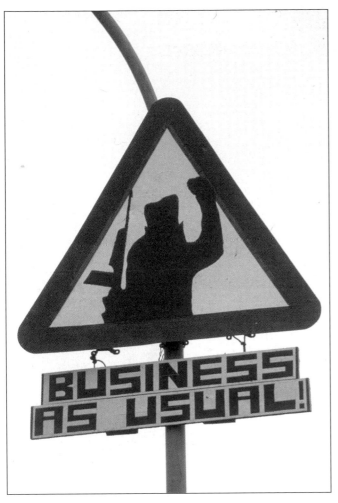

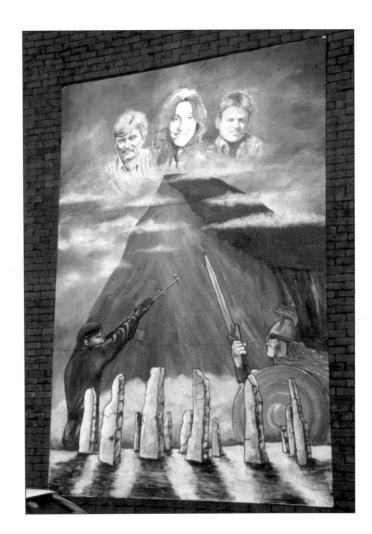

Plate 31
Camlough Road, Newry 1997
Silhouetted IRA sniper. 'Business as usual.'

Plate 32
Hawthorn Street, Belfast 1998
Armed IRA man, Celtic warrior, standing stones
and Rock of Gibraltar, portraits of Dan McCann,
Mairead Farrell and Sean Savage.

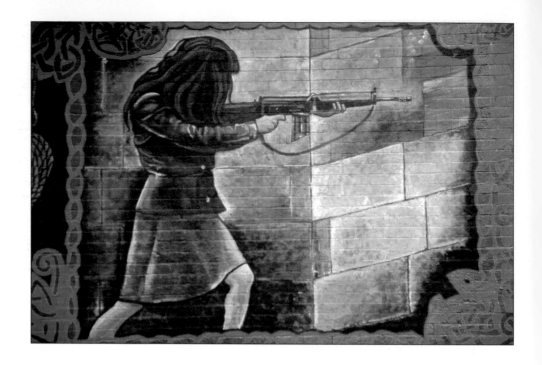

Plate 33
South Link, Belfast 1999
IRA woman in action.

Plate 34
Ballymurphy Road, Belfast 2002
Members of Cumann na mBan,
marching and armed; portraits of
local Republican women killed in
conflict.

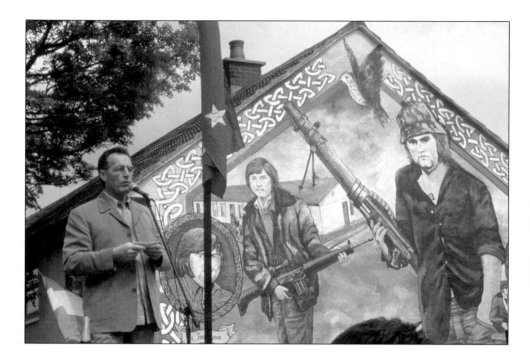

Plate 35
Ballymurphy Road, Belfast 2001
Portraits of IRA members
Jim Bryson and Paddy Mulvenna;
Gerry Kelly speaking at
dedication of mural.

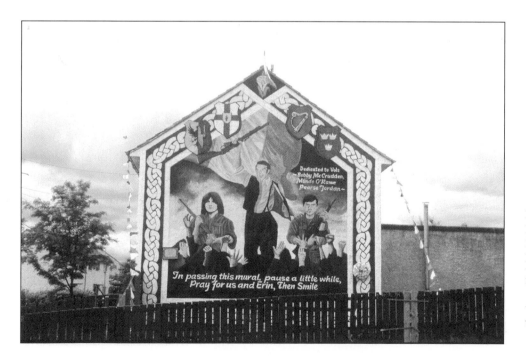

Plate 36
Divismore Drive, Belfast 2002
Portraits of IRA men Pearse Jordan,
Bobby McCrudden and
Mondo O'Rawe,
flags of four provinces of Ireland.
'In passing this mural, pause a little
while, pray for us and Erin,
then smile.'

19

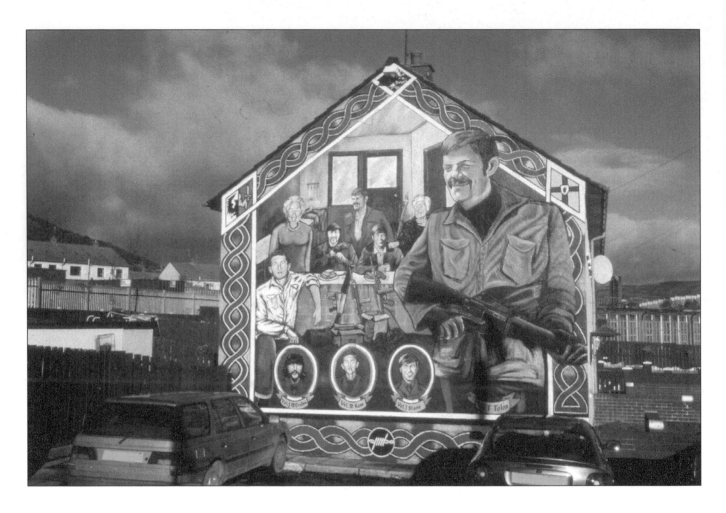

Plate 37
Ballymurphy Drive, Belfast 2001
IRA active service unit in local house,
portraits of IRA men Tommy Tolan, James
McGrillen, Michael Kane and John Stone.

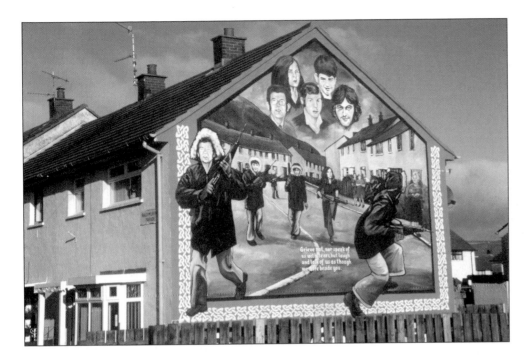

Plate 38
Glenalina Road, Belfast 2001
Local IRA members, portraits, and on patrol. 'Grieve not, nor speak of us with tears, but laugh and talk of us as though we were beside you.'

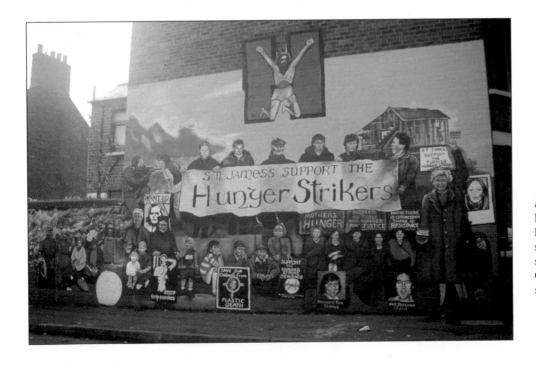

Plate 39
Hugo Street, Belfast 2001
Local (St James's area) protesters in support of 1981 republican hunger strikers, H of H-Blocks, liberated Christ, IRA firing party. 'St James's support the hunger strikers.'

21

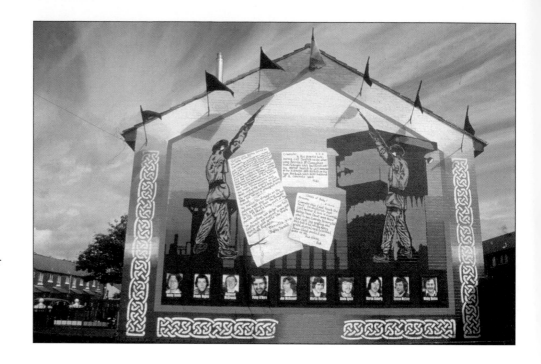

Plate 40
Ardoyne Avenue, Belfast 2001
IRA firing party, silhouette of
prison, 'comms' smuggled out of
prison, portraits of 10 dead hunger
strikers.

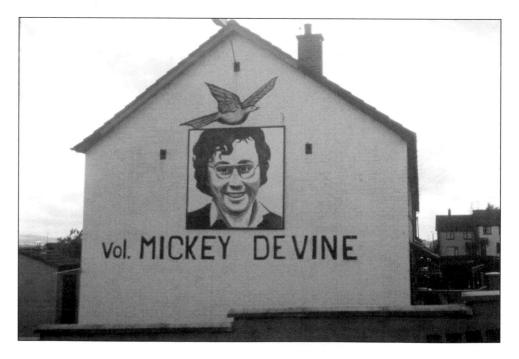

Plate 41
Rathkeele Way, Derry 2001
Portrait of Mickey Devine, hunger
striker.

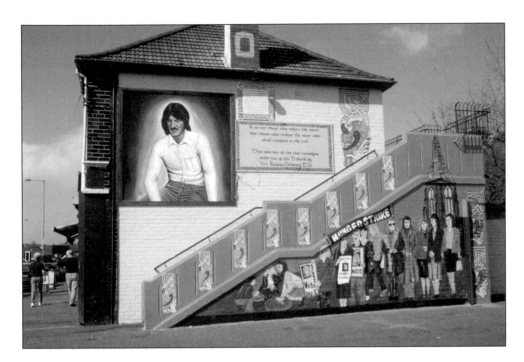

Plate 42
Slemish Way, Belfast 2001
Portrait of Kieran Doherty, hunger
striker, plus protesters

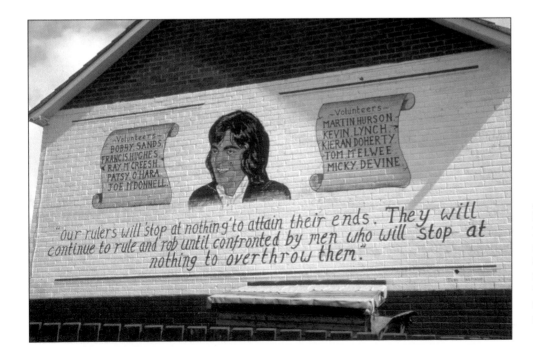

Plate 43
Lenadoon Avenue, Belfast 1998
Portrait of Joe McDonnell, hunger
striker, and names of all ten hunger
strikers. 'Our rulers will stop at
nothing to attain their ends. They
will continue to rule and rob until
confronted by men who will stop at
nothing to overthrow them.'

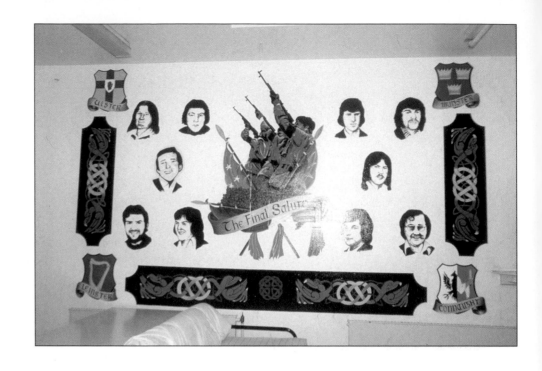

Plate 44
IRA wing, H Blocks, Long Kesh prison, 1999
IRA firing party, portraits of ten hunger strikers, shields of four provinces of Ireland.
'The final salute.'

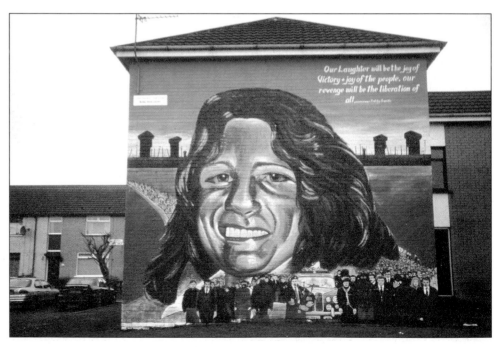

Plate 45
Gardenmore Road, Twinbrook, Belfast 1999
Portrait of Bobby Sands, hunger striker, silhouette of prison, funeral cortege. 'Our laughter will be the joy of victory and joy of the people, our revenge will be the liberation of all.'

24

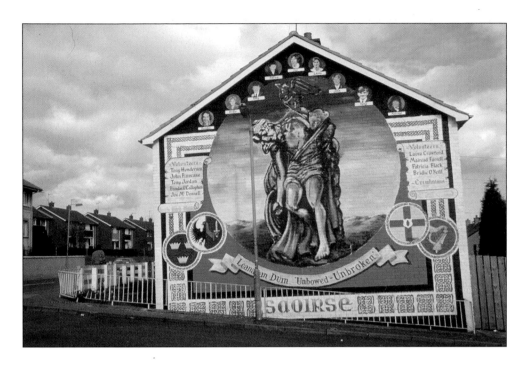

Plate 46
Lenadoon Avenue, Belfast 1996
Cuchulainn, with names and
portraits of local dead republicans.
'Unbowed – unbroken.'

Plate 47
IRA wing, H Blocks, Long Kesh,
2000
Celtic warrior and design, Tara
broach.

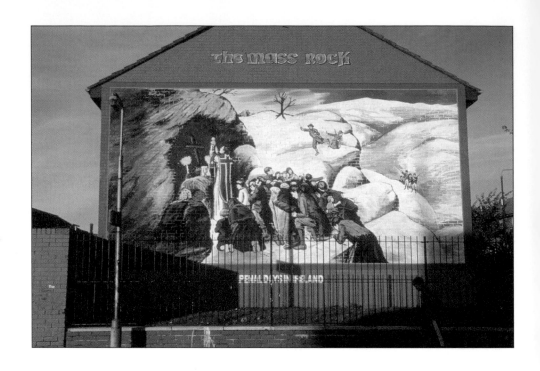

Plate 48
Ardoyne Avenue, Belfast 1996
Priest saying mass, while watchers
warn congregation of approaching
British soldiers. 'The mass rock.
Penal days in Ireland.'

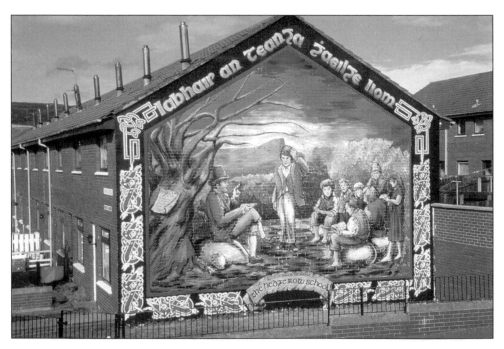

Plate 49
Ardoyne Avenue, Belfast 1996
Itinerant teacher and hedge row
school. 'Labhair an teanga ghaeilge
liom – speak the Irish language with
me.'

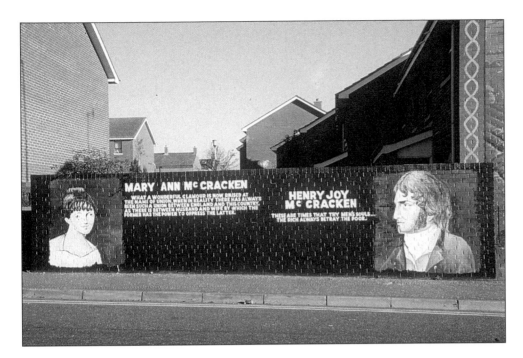

Plate 50
New Lodge Road, Belfast 1997
Mary Ann McCracken and Henry
Joy McCracken, heroes of 1798;
'… the rich always betray the poor'.

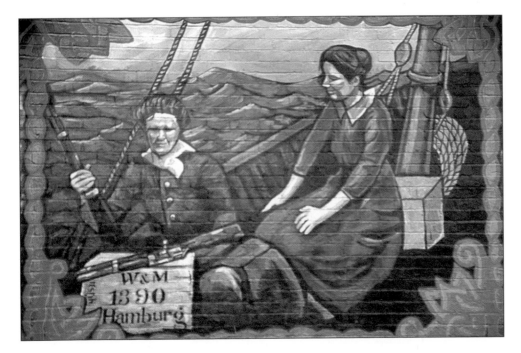

Plate 51
South Link, Belfast 1999
Mary Spring-Rice and Mary
Childers bring guns from Germany,
July 1914.

27

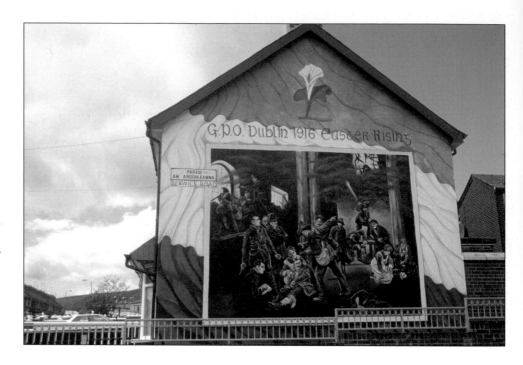

Plate 52
Berwick Road, Belfast 2002
James Connolly, dying, and Patrick
Pearse in GPO, Easter 1916. 'G.P.O.
Dublin 1916 Easter Rising.'

Plate 53
INLA wing, H Blocks,
Long Kesh, 2000
Portraits of seven signatories of
Proclamation of Republic, 1916,
GPO in background.

28

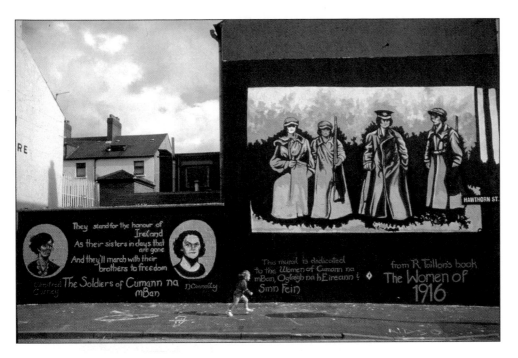

Plate 54
Hawthorn Street, Belfast 1996
Armed members of Cumann na
mBan, portraits of Winifred Carney
and Nora Connolly, chorus of song,
'The Soldiers of Cumann na mBan.'

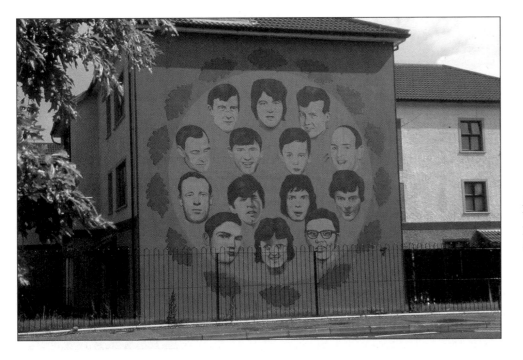

Plate 55
Westland Street, Derry 1999
Portraits of 14 victims of Bloody
Sunday, January 1972.

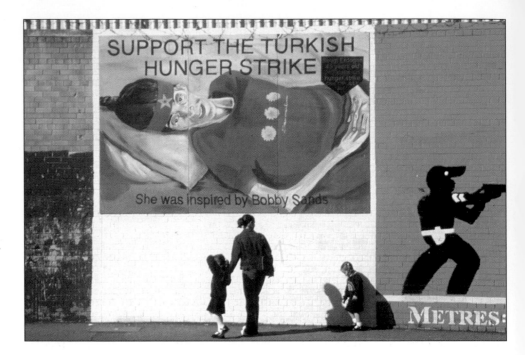

Plate 56
Falls Road, Belfast 2001
Portrait of Turkish hunger striker,
Sevgi Erdogan, who died July 2001.
'Support the Turkish hunger strike.
She was inspired by Bobby Sands.'

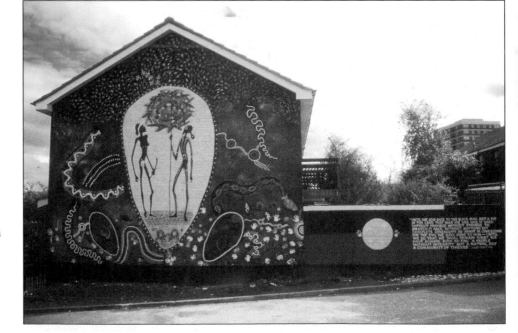

Plate 57
Ludlow Square, Belfast 1996
Australian aboriginal mural. 'Until
we give back to the black man just a
bit of the land that was his … we
shall remain what we have always
been so far: a people without
integrity, not a nation but a
community of thieves.'

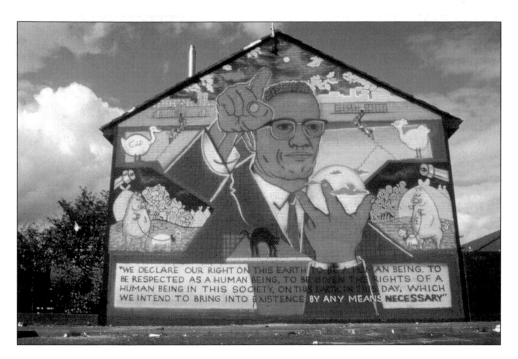

Plate 58
Ardoyne Avenue, Belfast 2002
Portrait of Malcolm X.
'We declare the right… to be
respected as a human being… which
we intend to bring into existence by
any means necessary'.

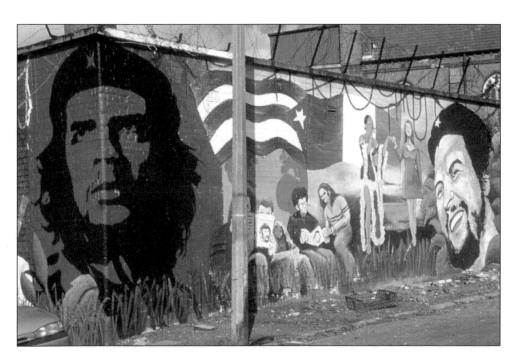

Plate 59
Shiels Street, Belfast 1998
Portraits of Che Guevara and Irish
republican prisoners, Cuban and
Irish flags, Cuban singer with
Irish dancer.

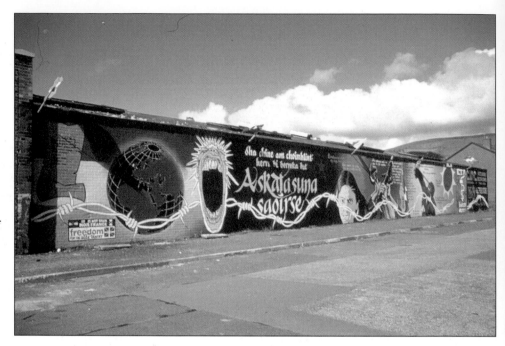

Plate 60
Beechmount Grove, Belfast 1997
Pro-Basque mural, showing aspects of
struggle – women, labour, nuclear
power and armed struggle. 'It is not
Spain nor France. Freedom for the
Basque country. Askatasuna – Saoirse
(freedom). Dha duine, aon choimhint
– herri bi borroka bat (two peoples,
one struggle).'

Plate 61
Falls Road, Belfast 2002
Pro-Palestinian mural; Israeli soldier
and Palestinian woman, 'Tiochaidh
ár lá' ('our day will come'), and
Arabic equivalent.

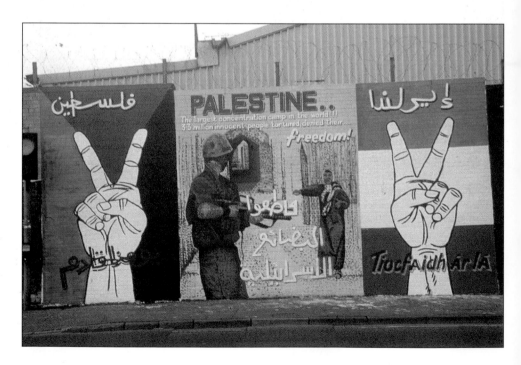

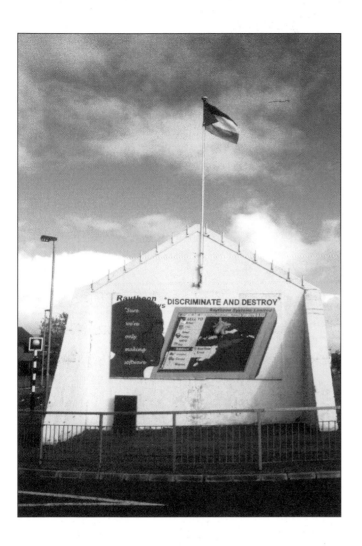

Plate 62
Rossville Street, Derry 2000
Computer screen, 3D rocket targeting East Timor.
'Discriminate and destroy. Raytheon says: "Sure
we're only making software".' Palestinian flag.

Plate 63
Hillman Street, Belfast 1999
Portraits of Leonard Peltier, 'native American US political
prisoner'. 'We must stand together to protect the rights of
others. No child to go hungry, no woman denied the right to
earn a living, no person denied health care or education, no
prisoner held for political reasons.'

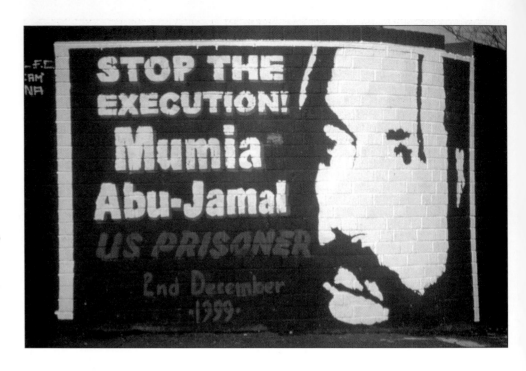

Plate 64
Conway Street, Belfast 1999
Portrait of Mumia Abu-Jamal. 'Stop
the execution! Mumia Abu-Jamal.
US prisoner. 2nd December 1999.'

Plate 65
Hillman Street, Belfast 1999
Portrait of Martin Luther King.
'Injustice anywhere is a threat to
justice everywhere… If colour,
religion or political opinions do make
us different, misery, oppression,
unemployment and exploitation make
us the same.'

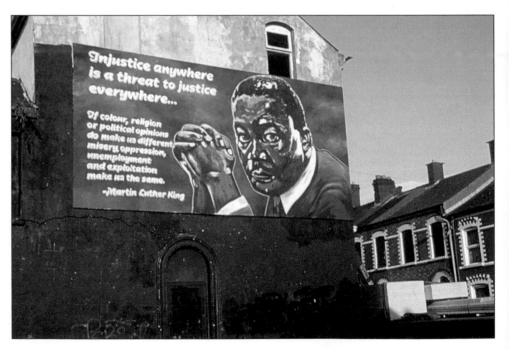

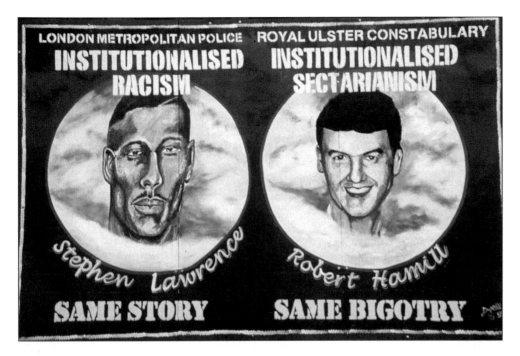

Plate 66
Artana Street, Belfast 1999
Portraits of Stephen Lawrence and Robert Hamill. 'London Metropolitan Police, institutionalised racism. Royal Ulster Constabulary, institutionalised sectarianism. Same story, same bigotry.'

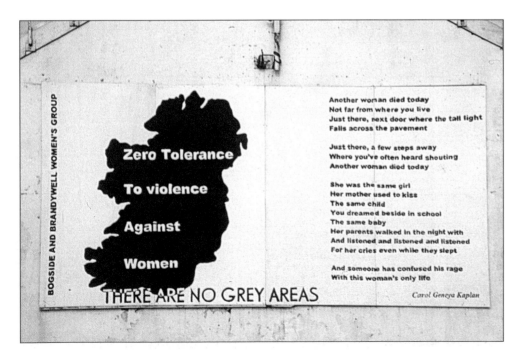

Plate 67
Rossville Street, Derry 2001
Map of Ireland, poem by Carol Geneya Kaplan. 'Zero tolerance to violence against women. There are no grey areas.'

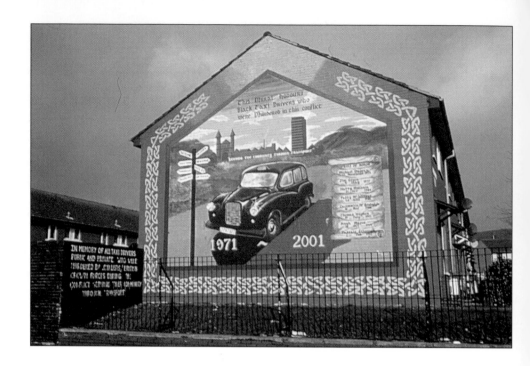

Plate 68
Ardoyne Avenue, Belfast 2001
Black taxi and roll of honour to
'black taxi drivers who were
murdered in this conflict', 1971-
2001. 'Serving the community
through transport.'

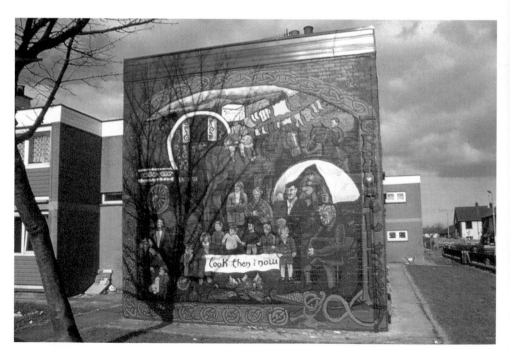

Plate 69
Shaws Road, Belfast 1996
Scenes from the life of the
Travelling community. 'Look then
and now.'

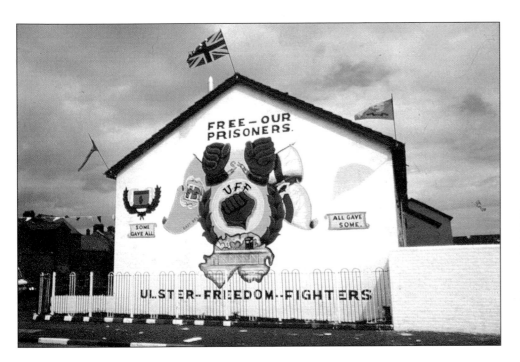

Plate 70
Lord Street, Belfast 1997
Red hands, broken chains, map of
Northern Ireland with prison walls,
UDA and Ulster flags. 'Some gave
all. All gave some. Free our
prisoners. Ulster Freedom Fighters.'

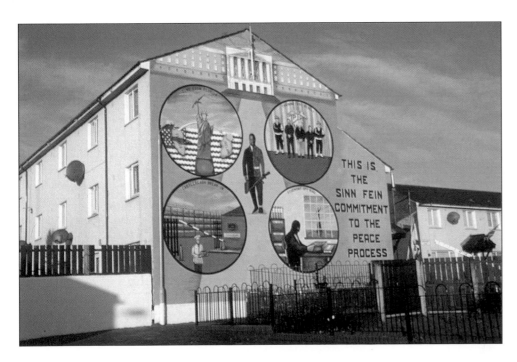

Plate 71
Boundary Walk, Belfast 2003
Sinn Féin President Gerry Adams
with brief case and gun. 'This is the
Sinn Fein commitment to the peace
process' – 'Guns from Florida',
'Training FARC rebels',
'Castereagh break in',
'Stormont spy ring'.

37

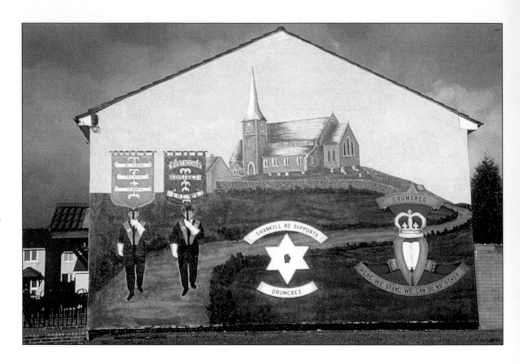

Plate 72
North Boundary Street, Belfast 2000
Drumcree church, two Orange
marchers carrying bannerettes.
'Shankill Road supports Drumcree.
Drumcree – here we stand; we can
do no other.'

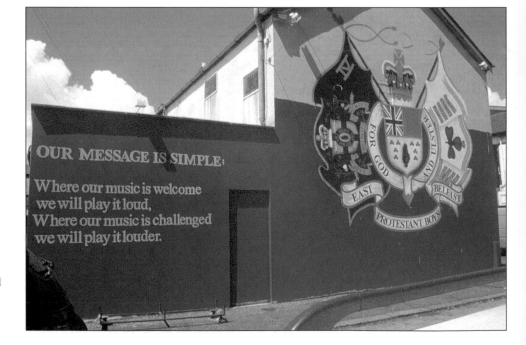

Plate 73
Hemp Street, Belfast 2002
East Belfast Protestant Boys Flute
Band, UVF flags and emblems.
'Our message is simple: where our
music is welcome we will play it
loud, where our music is challenged
we will play it louder.'

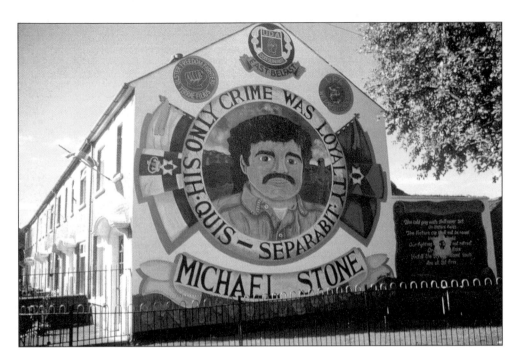

Plate 74
Templemore Avenue, Belfast 2000
Portrait of Michael Stone with UDA
flags and symbols. 'His only crime
was loyalty. Quis separabit (who
will separate).'

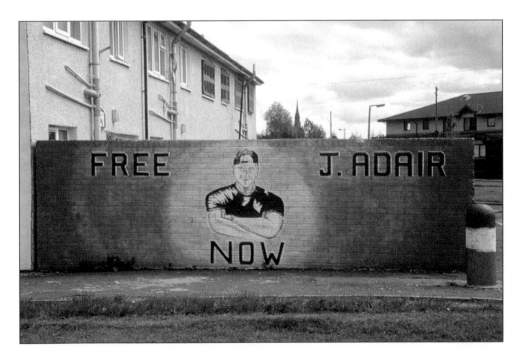

Plate 75
Hopewell Crescent, Belfast 2001
Portrait of Johnny Adair. 'Free J.
Adair now.'

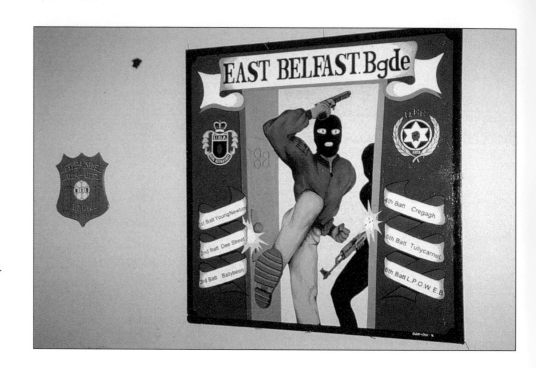

Plate 76
UDA wing, H Blocks,
Long Kesh, 2000
Armed and masked UDA man of
East Belfast Brigade kicks in door.

Plate 77
Mount Vernon Walk, Belfast 2001
Armed and masked UVF men with
UVF symbols.
'Prepared for peace, ready for war.'

Plate 78
Hopewell Crescent, Belfast 2000
Armed and masked UFF member.

Plate 79
Rathcoole Drive, Newtownabbey,
Belfast 1999
Armed and masked UFF men
in action.

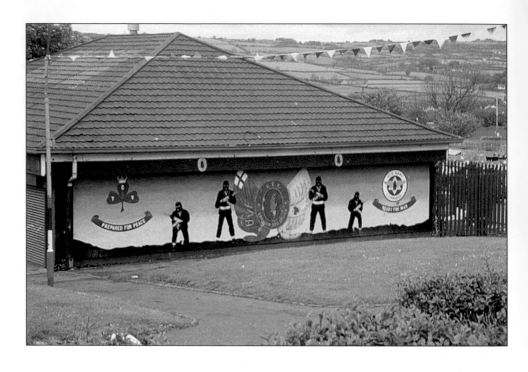

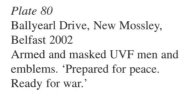

Plate 80
Ballyearl Drive, New Mossley,
Belfast 2002
Armed and masked UVF men and
emblems. 'Prepared for peace.
Ready for war.'

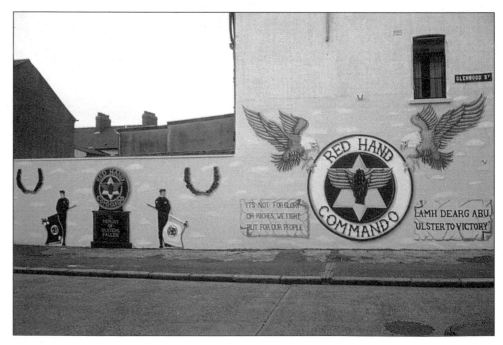

Plate 81
Glenwood Street, Belfast 1999
Eagles and Red Hand Commando
personnel and emblems. 'It is not
for glory or riches, we fight but for
our people. Lamh dearg abu (red
hand for ever). Ulster to victory.'

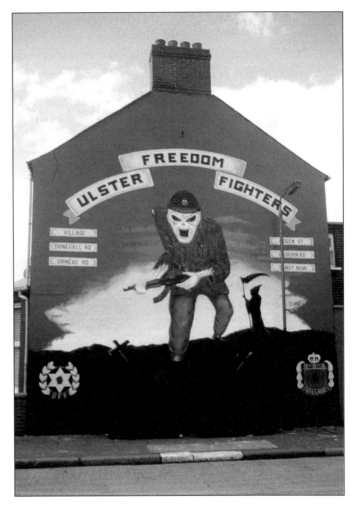

Plate 82
Mersey Street, Belfast 1996
UVF men and emblem. 'We are pilgrims, master;
we shall go always a little further.'

Plate 83
Tavanagh Street, Belfast 2001
Iron Maiden's 'Eddie' as a loyalist hero, and the
Grim Reaper.

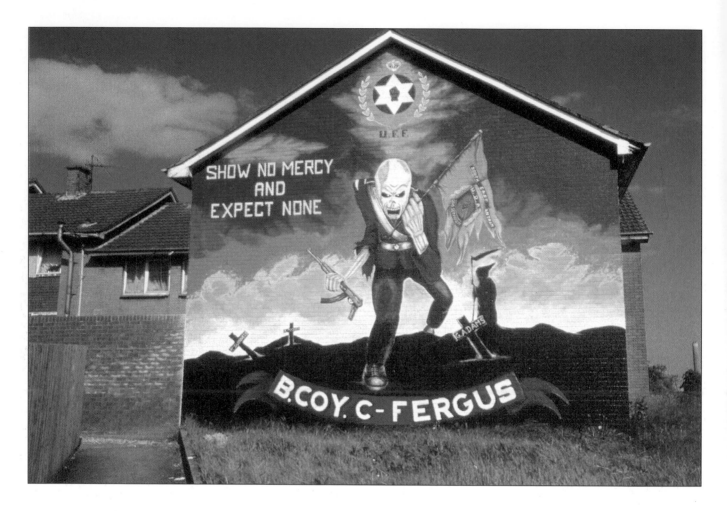

Plate 84
Deans Park, Carrickfergus, 2000
Iron Maiden's ' Eddie', and the Grim Reaper. Crosses
bearing the names of Gerry Adams, Martin McGuinness and
Alex Maskey, Sinn Féin. 'Show no mercy and expect none.'

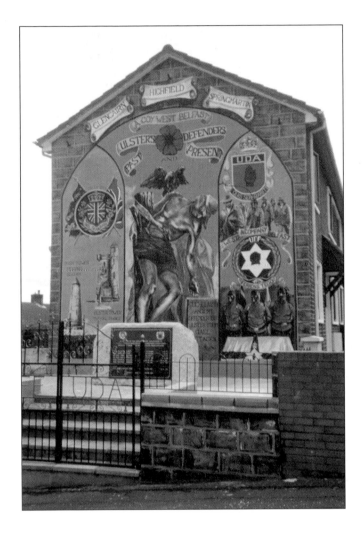

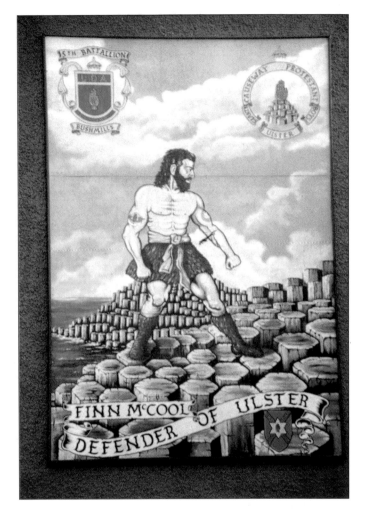

Plate 85
Highpark Drive, Belfast 2001
Cuchulainn, first world war memorials and UDA
men and emblems. 'Cuchulainn, ancient defender
of Ulster from Gael attacks.'

Plate 86
Bushmills, County Antrim 2000
Finn McCool, Giant's Causeway and UDA
emblems. 'Finn McCool, defender of Ulster.'

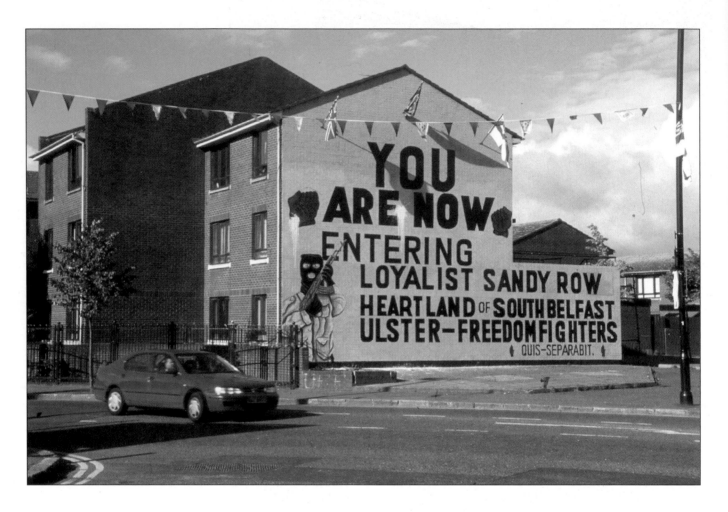

Plate 87
Sandy Row, Belfast 2001
Armed UFF man and clenched Red Hands. 'You are now entering
loyalist Sandy Row, heartland of South Belfast. Ulster Freedom Fighters.
Quis separabit.'

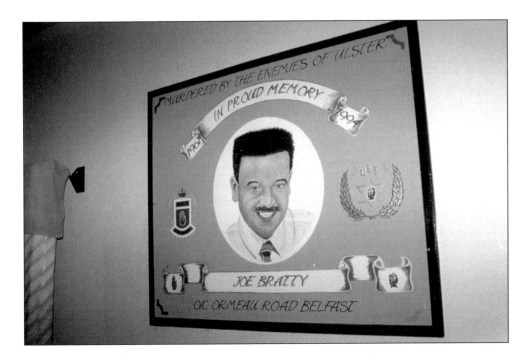

Plate 88
UDA wing, H Blocks,
Long Kesh 2000
Memorial to Joe Bratty, OC in
South Belfast. 'Murdered by the
enemies of Ulster.'

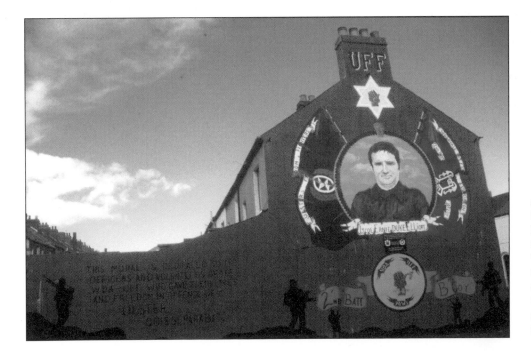

Plate 89
Ohio Street, Belfast 2001
Memorial to Ernie 'Duke' Elliott,
with members and emblems of
Woodvale Defence Association and
UFF. 'This mural is dedicated to the
officers and volunteers of the WDA-
UFF who gave their lives and
freedom in defence of Ulster.
Quis separabit.'

47

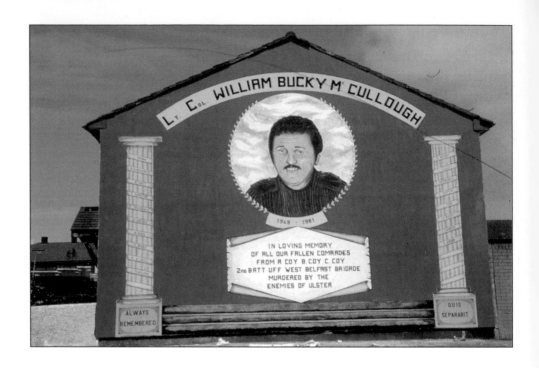

Plate 90
Hopewell Crescent, Belfast 2000
Memorial to William 'Bucky'
McCullough, UFF and 'all our
fallen comrades'. 'Always
remembered. Quis separabit.'

Plate 91
Hopewell Crescent, Belfast 2000
Memorial to Billy Wright, 'King
Rat'. 'Loyalist martyr.'

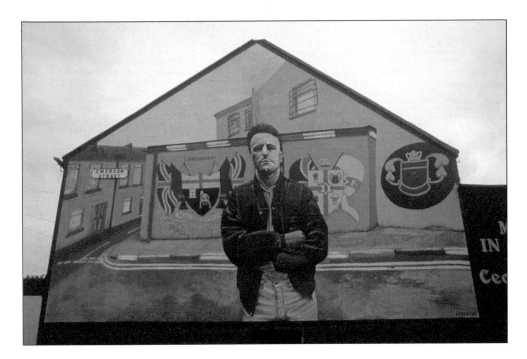

Plate 92
Emerson Street, Derry 1999
Memorial to Cecil McKnight, with
portrayal of another local mural and
UDA emblem.

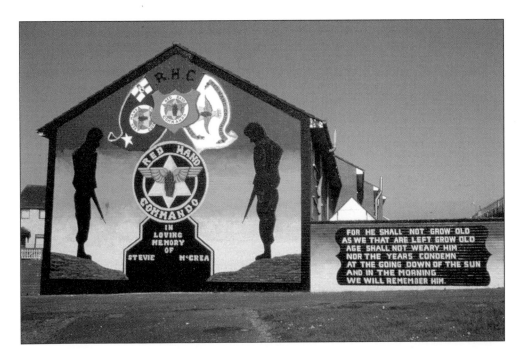

Plate 93
Hopewell Crescent, Belfast 2000
Memorial to Stevie McCrea of the
Red Hand Commando, with RHC
flags and emblems. 'For he shall not
grow old as we that are left grow
old. Age shall not weary him or the
years condemn. At the going down
of the sun and in the morning
we will remember him.'

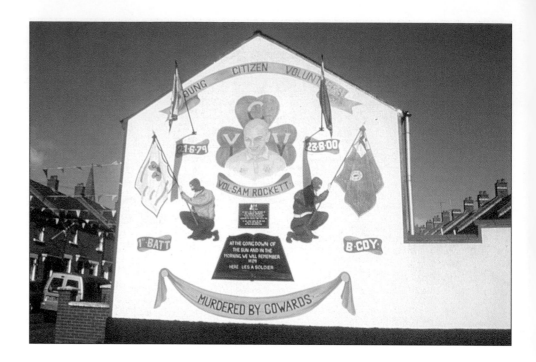

Plate 94
Disraeli Street, Belfast 2000
Memorial to Sam Rockett, Young
Citizen Volunteers, with YCV and
UVF flags and emblems. 'At the
going down of the sun and in the
morning we will remember him.
Here lies a soldier. Murdered by
cowards.'

Plate 95
Mount Vernon Park, Belfast 1999
Soldier of 36th Ulster Division, with
names of battlefields of
World War I, and UVF emblems.

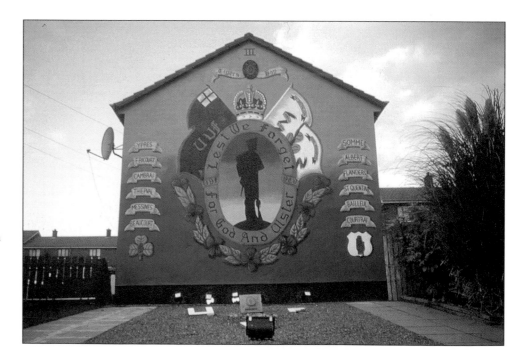

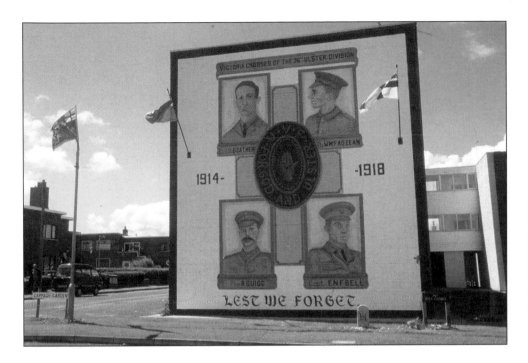

Plate 96
South Bank, Cregagh, Belfast 2002
Portraits of members of 36th Ulster
Division awarded Victoria Crosses
in World War 1: Geoffrey Cather,
William McFadzean, Robert Quigg,
Eric Bell, and UVF emblem. 'Lest
we forget.'

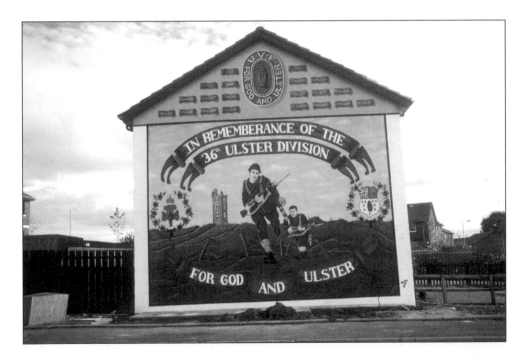

Plate 97
Cashel Drive, Monkstown,
Newtownabbey 1996
36th Ulster Division in action in
World War 1, along with names of
battlefields and UVF emblem. 'In
remembrance of the 36th Ulster
Division. For God and Ulster.'

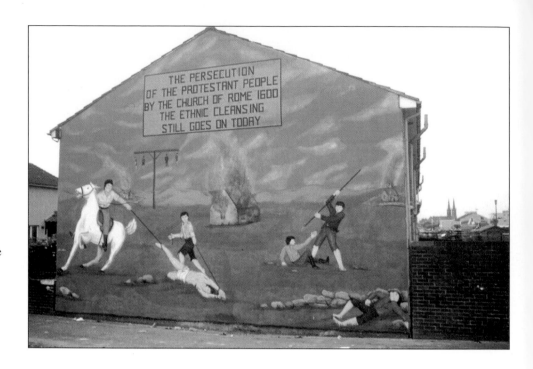

Plate 98
Hopewell Crescent, Belfast 2000
Portrayal of 1641 rising. 'The
persecution of the Protestant people
by the church of Rome 1600 [sic].
The ethnic cleansing still
goes on today.'

Plate 99
Moscow Street, Belfast 2002
Ulster portrayed as maiden during
Home Rule crisis. 'Deserted! Well –
I can stand alone.' Masked woman
with gun and man on tractor. 'A
protestant farmer's wife guards her
husband against sectarian attack
from across the border.'

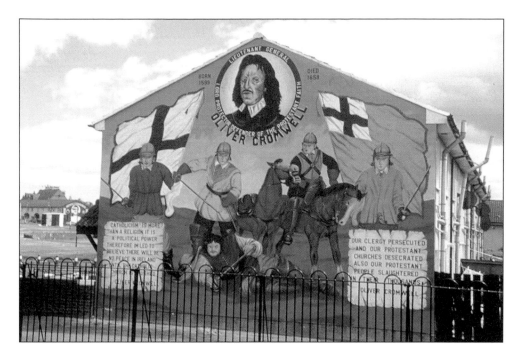

Plate 100
Shankill Parade, Belfast 2002
Portrayal of Oliver Cromwell's
activities in Ireland. 'Catholicism is
more than a religion; it is a political
power. Therefore I'm led to believe
there will be no peace in Ireland
until the Catholic church
is crushed.'

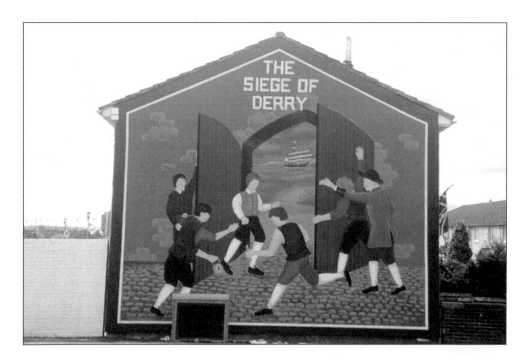

Plate 101
Hopewell Crescent, Belfast 2000
Apprentice boys shut the gates of
Derry at beginning of siege, 1689.

53

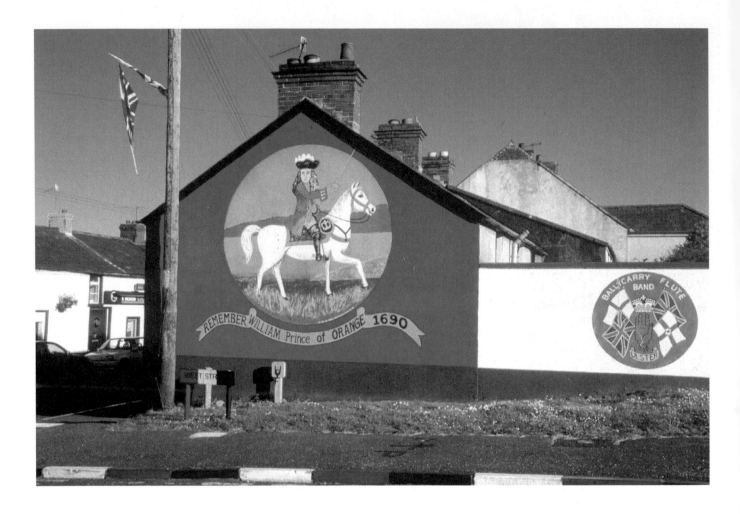

Plate 102
West Street, Ballycarry, County Antrim 2000
Traditional King Billy mural. 'Remember
William of Orange, 1690.'

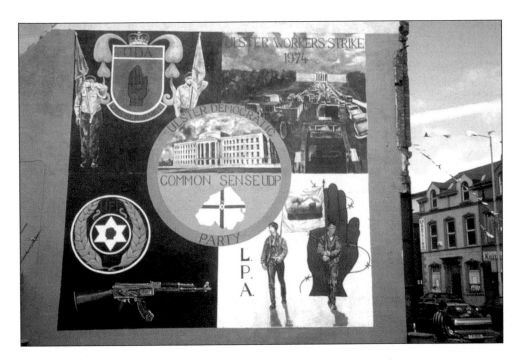

Plate 103
Canmore Street, Belfast 1998
Masked loyalists, weapons and
Ulster Workers' Council strike,
1974. Emblems of Ulster Defence
Association, Ulster Freedom
Fighters, Loyalist Prisoners'
Association and
Ulster Democratic Party.

Plate 104
Blythe Street, Belfast 1998
Masked loyalists and barricades
during Ulster Workers' Council
strike, 1974 (detail).

55

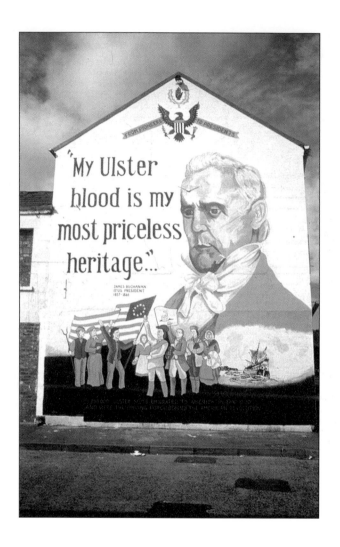

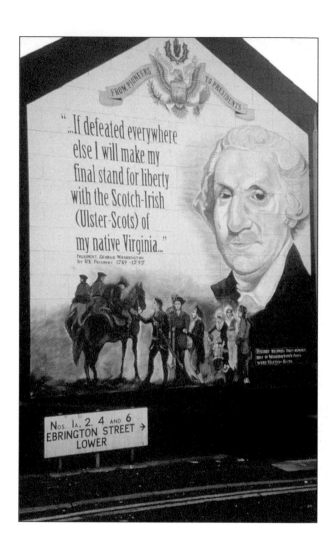

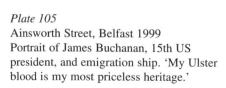

Plate 105
Ainsworth Street, Belfast 1999
Portrait of James Buchanan, 15th US
president, and emigration ship. 'My Ulster
blood is my most priceless heritage.'

Plate 106
Ebrington Street, Derry 2000
Portrait of George Washington, 1st US president,
and Continental Army. 'If defeated everywhere
else I will make my final stand for liberty with the
Scotch-Irish (Ulster-Scots) of my native Virginia.'

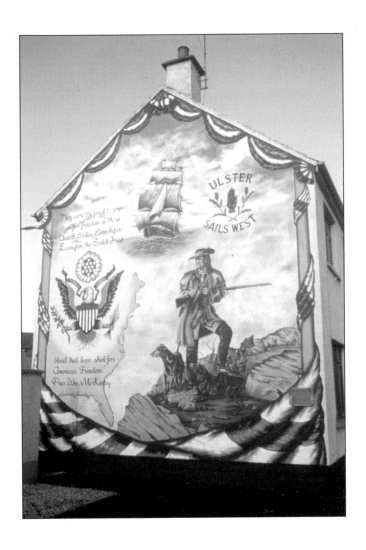

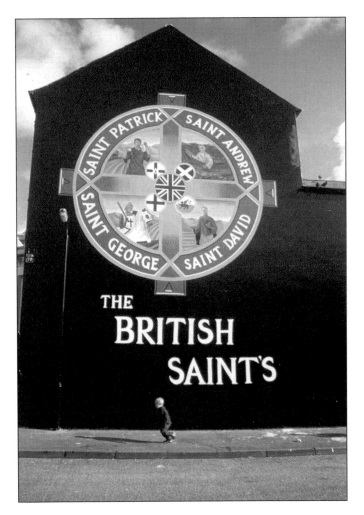

Plate 107
Glebeside, Ballymoney, County Antrim 2002.
Portrait of Davy Crockett.
'They were the first to proclaim for freedom
in these United States…'

Plate 108
Canada Street, Belfast 2001
The British saints –
Patrick, Andrew, David, George.

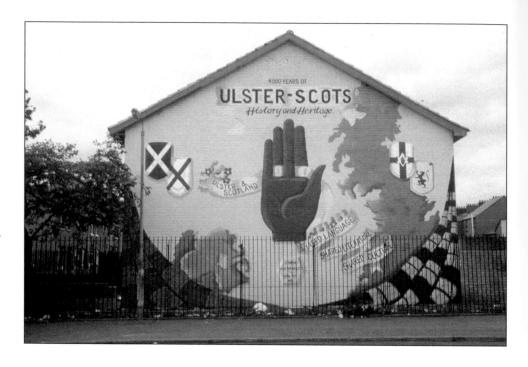

Plate 109
Avoniel Road, Belfast 1999
Red Hand, Ulster and Scottish flags.
'4000 years of Ulster-Scots history
and heritage. Shared language,
shared literature, shared culture.
Dinnae houl yer wheest, houl yer
ain! (Don't be silent, stand up for
yourself!).'

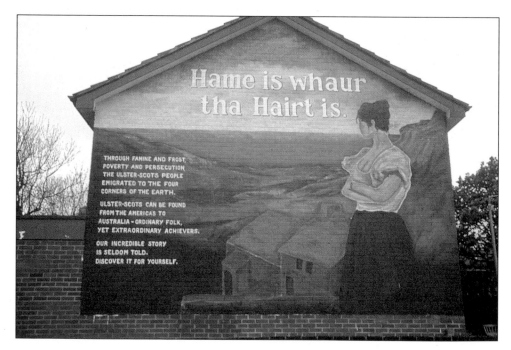

Plate 110
Ballyearl Drive, New Mossley,
Belfast 2002
Peasant woman and rural scene.
'Hame is whaur tha hairt is (home is
where the heart is). … Our
incredible story is seldom told.
Discover it for yourself.'

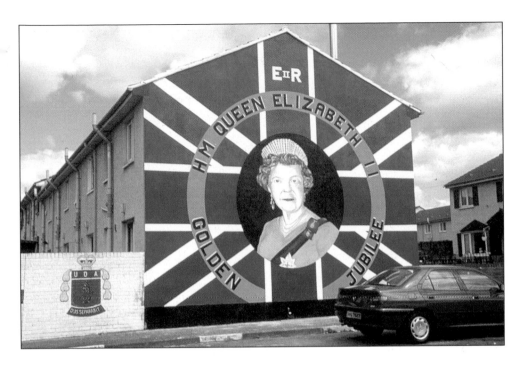

Plate 111
Hopewell Crescent, Belfast 2002
Portrait of Queen Elizabeth II
on occasion of her golden jubilee.

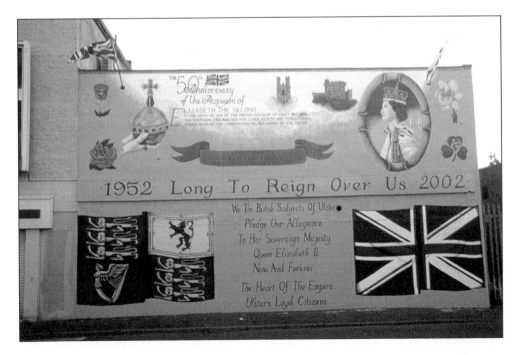

Plate 112
Shankill Road, Belfast 2002
Portait of Queen Elizabeth II and
royal symbols and flags. 'We the
British subjects of Ulster pledge our
allegiance to her sovereign majesty
Queen Elizabeth II now and forever.
The heart of the empire,
Ulster's loyal citizens.'

59

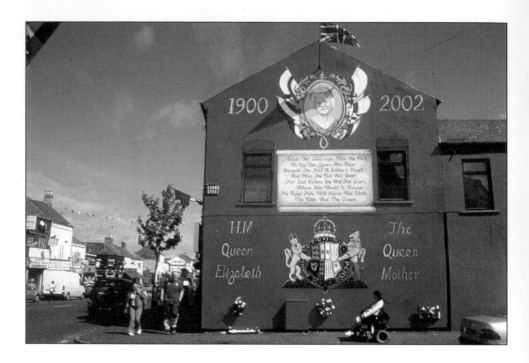

Plate 113
Shankill Road, Belfast 2002
Portrait of Queen Elizabeth, the
Queen Mother.
'No rebel hate will harm this state,
the bible and the crown.'

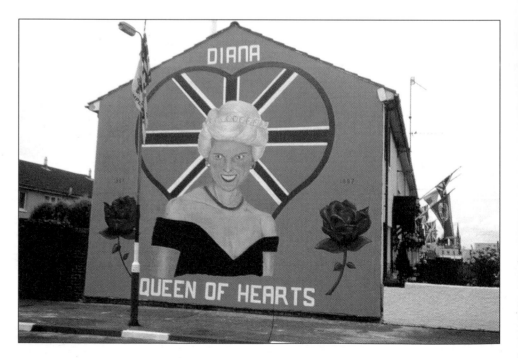

Plate 114
Hopewell Crescent, Belfast 2000
Portrait of Diana Spencer,
'Queen of Hearts.'